89 90 9? ᛋᚢᛚᛚᛟ 95 96 98
 /| /|| | /| //

10
/

MASTERS
of the SEA

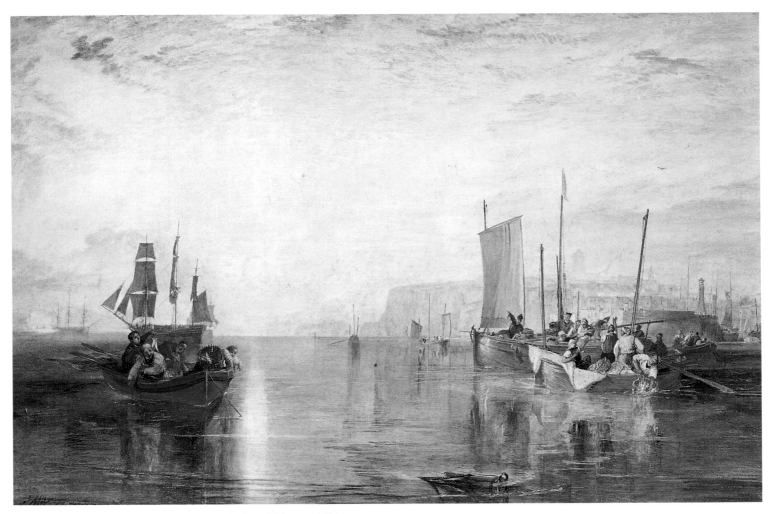

1 Joseph Mallord William Turner *Whiting Fishing off Margate*, 1822.
 Cat. 85.

This watercolour was exhibited with a companion piece, *The Storm*
(British Museum), at W. B. Cooke's gallery in Soho Square in 1823. It
was engraved in mezzotint by Thomas Lupton in 1825, and issued by
Turner himself, perhaps as part of an intended series of 'Marine Views'.

MASTERS of the SEA

British Marine Watercolours

ROGER QUARM
and
SCOTT WILCOX

Phaidon Press, Oxford
in association with
The National Maritime Museum, Greenwich
and The Yale Center for British Art, New Haven

Acknowledgements

758.2

We should very much like to thank the following for their help during research and in facilitating exhibition loans: Anthony Reed, Jane Munro, Sarah Hyde, Gregory Smith, Andrea George, Jill Kennedy, Evelyn Newby, Sheila O'Connell, The Hon Mrs Jane Roberts, Miss Henrietta McBurney and George Gordon.

At the Yale Center we would like to thank Constance Clement, Teresa Fairbanks, Lyn Koehnline, Barbara Allen, Michael Marsland and Timothy Goodhue. Particular thanks are due to Candace Clements, graduate intern at the Yale Center, for compiling catalogue information.

We would like to thank the following at the National Maritime Museum: Claire Venner, Rosemary Clarey, Stephen Deuchar, Christopher Terrell, Robert Baldwin, Roger Morriss, Chrissie McLeod, Lindsey Macfarlane, Joan Dormer, David Lyon, Jane Dacey, Lionel Willis, Gary Stewart, Denis Stonham, Bob Todd and the Historic Photographs Section; James Stevenson, Barrie Cash and the staff of the Photographic Department. We are grateful to the Conservation Division for their very large contribution in preparing items for exhibition, in particular Ann Leane, Bryan Clarke, Jane Burnett, Sally Anne Hamley, Paul Cook, John Moores, George Spalding, Bernard Radford and Eric Nichols.

6-89 BT 2200

Phaidon Press Limited, Littlegate House, St Ebbe's Street, Oxford OX1 1SQ

First published 1987
© 1987 Phaidon Press Limited

British Library Cataloguing in Publication Data

Masters of the sea: British marine
 watercolours, 1650–1930.
 1. Marine painting, British—Exhibitions
 2. Watercolor painting, British—Exhibitions
 I. Quarm, Roger II. Wilcox, Scott
 III. Yale Center for British Art
 IV. National Maritime Museum
 758'.2'0941074 ND2272.G7

 ISBN 0-7148-2490-9
 ISBN 0-7148-2491-7 Pbk

Designed by Sarah Tyzack

Printed in Great Britain by Balding + Mansell UK Limited

Published for the exhibition, *Masters of the Sea: British Marine Watercolours 1650–1930*, organized by the National Maritime Museum, Greenwich, in association with the Yale Center for British Art, New Haven.
Yale Center for British Art, New Haven: 10 June–2 August 1987
National Maritime Museum, Greenwich: 25 August–25 October 1987

Contents

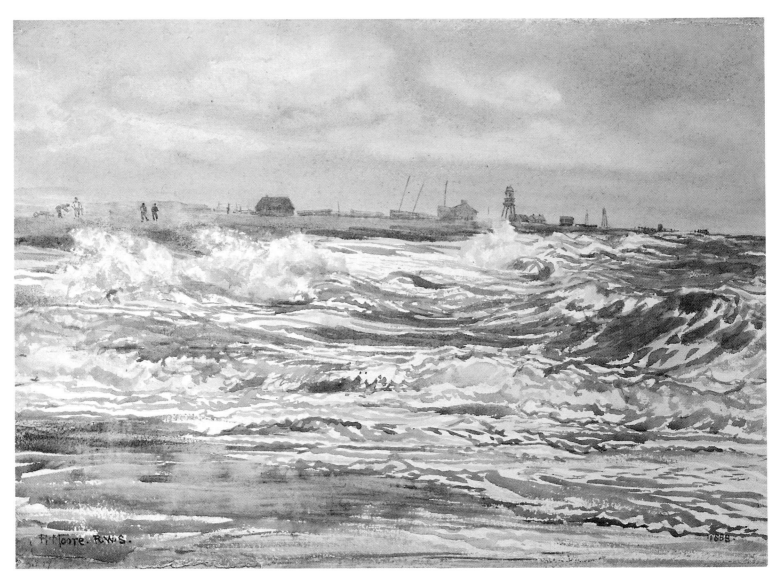

2 Henry Moore *Lowestoft*, 1888. Cat. 142.

From his early work as a landscape painter, Moore turned in the late
1850s almost exclusively to marine painting. Rather than concern himself
with details of ships and shipping, he painted the sea for its own sake,
making careful studies of the movement of waves: 'I thought I had never
seen the wet, polished surface of water truthfully given by *anybody*.'

Foreword

Watercolour painting, like poetry and drama, is something for which the British have always shown a natural talent. It is also a medium which has a long association with the sea. The earliest charts were drawn with pen and watercolours on vellum; seamen frequently illustrated their log-books with carefully drawn coastal profiles to identify landmarks; naval officers were encouraged to make watercolour drawings of foreign ports and enemy fortifications. The National Maritime Museum at Greenwich has many examples of this practical use of the medium, as well as an unrivalled collection of drawings and watercolours depicting individual ships, harbour scenes and naval actions.

The Print Room at Greenwich contains around 70,000 items, the bulk of the collection being formed in the 1930s by the generosity of Sir James Caird on the advice of the Museum's first director, Sir Geoffrey Callendar. It includes two major collections, those of A. G. H. Macpherson and Sir Bruce Ingram, together with some shrewd purchases of the contents of artists' studios, notably that of W. L. Wyllie.

A selection from the material held at Greenwich has been combined with the wide-ranging collections of the Yale Center for British Art at New Haven to produce the first serious survey of marine watercolours to be held for many years. The Yale Center is strong in precisely those areas which are not covered at Greenwich. It has outstanding examples of work by Turner, Constable, Cotman, David Cox, Whistler and other artists who were not marine specialists but frequently painted harbour scenes, fishing boats, rocky coasts and sandy beaches.

The Yale Center owes its origins to the generosity of Paul Mellon, who gave his magnificent collections of British paintings, drawings, prints and rare books to Yale University in 1966. The collections are housed in a building designed by the distinguished American architect Louis Kahn, and opened to the public in 1977.

We would like to pay tribute to the vision of Paul Mellon in setting up the Yale Center, and to thank him for lending a number of items from his private collection to this exhibition. We would also like to thank the directors and staff of the Victoria and Albert Museum, the Fitzwilliam Museum in Cambridge, the Whitworth Art Gallery in Manchester, and the Cecil Higgins Art Gallery in Bedford for lending watercolours from their collections. Sotheby's, London, made a financial contribution towards the cost of the exhibition and we would like to thank them for their support.

We are grateful to Roger Quarm, curator of Prints and Drawings at Greenwich, and Scott Wilcox, assistant curator of Prints and Drawings at the Yale Center, for organizing the exhibition and writing the catalogue. Dr David Cordingly, Head of Pictures at Greenwich, has been closely involved in the project at every stage of its implementation.

Richard Ormond
Director, National Maritime Museum

Duncan Robinson
Director, Yale Center for British Art

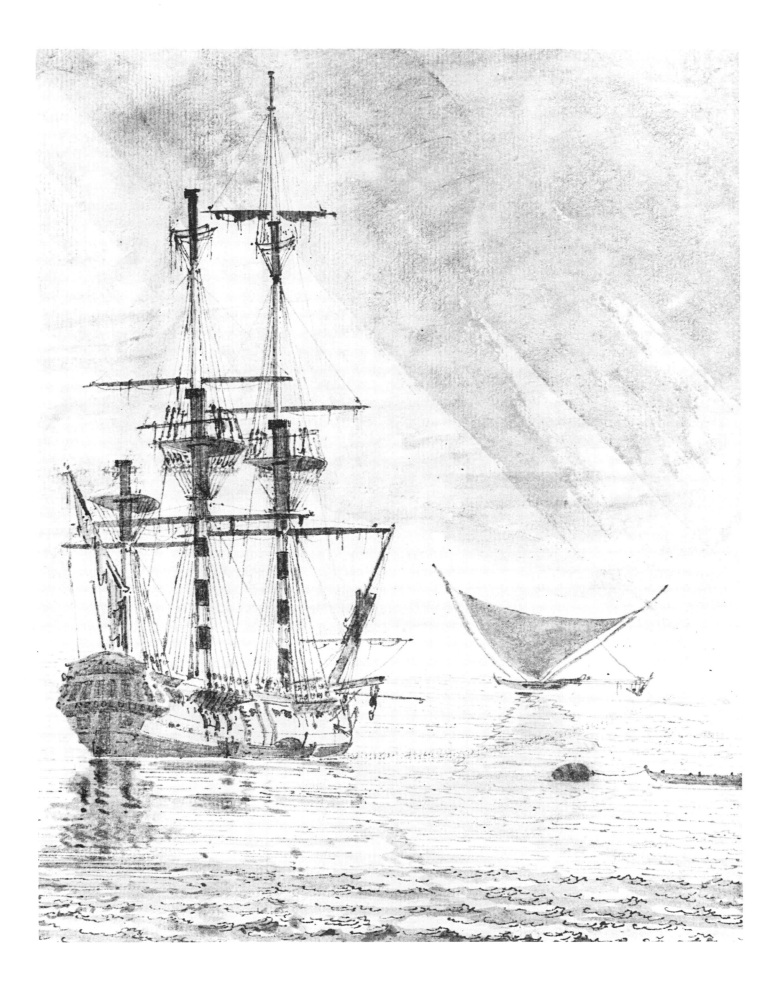

The Art
of Marine Drawing

ROGER QUARM

Many are the obstacles to the attainment of a proficiency in drawing Marine subjects, particularly as it is not only requisite that a person desirous of excelling in this Art should possess a knowledge of the construction of a Ship, or of what is denominated '*Naval Architecture*' together with the proportion of masts and yards, the width depth and cut of the sails, & c; but he should likewise be acquainted with Seamanship.[1]

The publication in 1805 of the *Liber Nauticus and Instructor in the Art of Marine Drawing* by John Thomas Serres indicates that by the end of the eighteenth century marine drawing was accepted as a distinct and legitimate specialization for artist and amateur alike. Part I describes in detail, with plates, the parts of a ship, the drawing of water, how ships sail, rates or classes of ships, and the different ranks of admirals. Part II consists of twenty-four plates in aquatint after drawings by his long-dead father Dominic Serres 'made expressly for the instruction of a Nobleman', and presumably to be copied: 'In short, so comprehensive is this work, that there is scarcely any kind of bark, which floats on the water, that is not delineated— a circumstance that must greatly facilitate the study of Marine Drawing in general.'[2]

The practice taught to naval officers of drawing coastal views for the purpose of identification and as an aid to navigation had originated in the late sixteenth century, and its aims were strictly practical. An example may be seen in the drawings made by Commander Peircy Brett during his voyage around the world with Captain George Anson, 1740–44 (Plate 2). As Marine Draughtsman to the Admiralty Board, John Thomas Serres himself had learnt this discipline and later taught it at the Chelsea Naval Academy; the coastlines in many of his drawings clearly derive from this.

Over the last hundred and fifty years the term 'marine painting' has evolved to describe any pictures in which the sea is a major element. Thus it has become a term which may describe the marines of Turner or Whistler; or paintings of the sea by the Pre-Raphaelites or the Impressionists. In the eighteenth century, however, the category was a precise one, with as distinct a definition as landscape or portrait painting. The term implied the accurate portrayal of nautical detail (in its broadest sense) as well as historical fact. For the specialist marine painter, familiarity with subject was all important. This essential interest often originated from practical experience of the sea or dockyards. Indeed a number of marine artists went to sea before they became artists, among them Nicholas Pocock, Dominic Serres and George Chambers; Robert Cleveley worked as a caulker in Deptford Dockyard.[3]

It is usual for a discussion of English marine painting to begin at the arrival from Holland in

1 William Hodges *The Resolution in the Marquesas*, 1774. Cat. 31. Although Hodges produced dramatic watercolours of the *Resolution* and the *Adventure* in the southern ice in the Antarctic Ocean (Mitchell Library, State Library of New South Wales), this drawing is nevertheless striking in its broad diagonal washes in the sky and the general effect of suffused sunlight. The calligraphic pen work in the drawing of the waves is also typical. It is possible that the drawing may be dated between Cook's arrival (from Easter Island) at Tahuata on 8 April and his departure, sailing again for Tahiti, on 12 April 1774. The canoe in the background is of a type known in the Marquesas, 'made of wood and pieces of a bark of a soft wood . . . some have a sort of latten sail made of mating', (Cook, *Journals*, II, 12 April 1774, p.376), and it has been suggested that Hodges made the drawing from a boat while the *Resolution* was at anchor in Vaitahu Bay (R. Joppien and B. Smith, *The Art of Captain Cook's Voyages*, II, London and New Haven, 1985, p. 205).

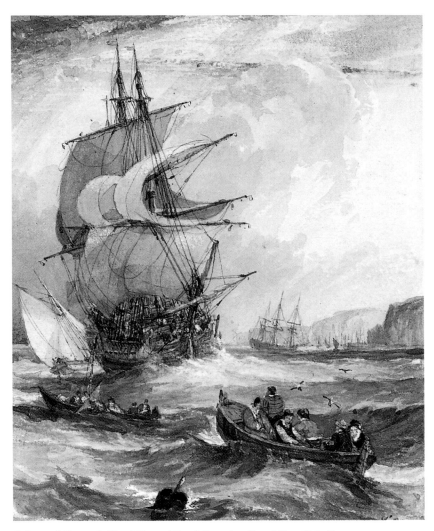

3 Samuel Owen *Sailing Ships and Small Boats in a Rough Sea off the Coast.*
Cat. 70.

Little is known about Samuel Owen who, in the early years of the
nineteenth century, absorbed the influences of Girtin and Turner into a
distinctive style of marine watercolours, combining atmospheric breadth
and dramatic compositions with precise nautical detail.

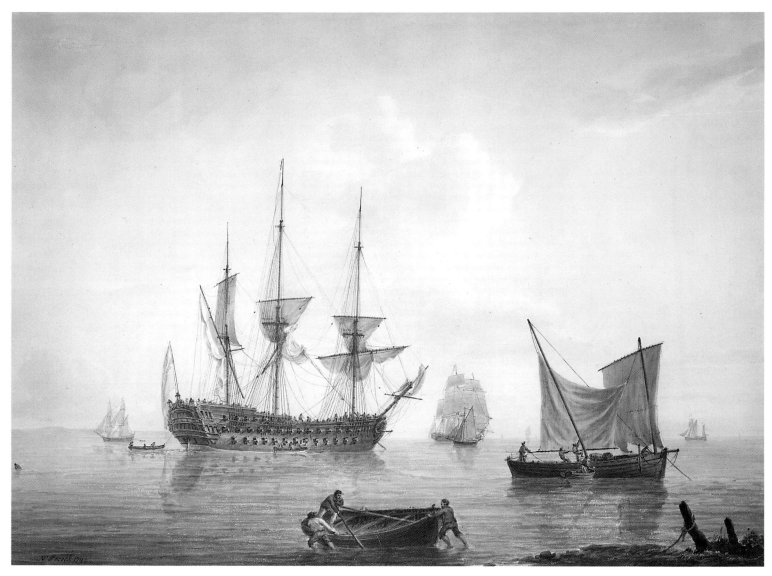

4 Nicholas Pocock *Men-of-war at Anchor in a Calm*, 1794. Cat. 56.

Although Pocock's contemporary reputation rested largely on his depictions of the great sea battles with France, he was also adept at picturesque landscapes and more peaceful marine subjects, such as this view of a two-decker in a calm. This watercolour dates from 1794—the same year in which he was present at the Battle of the First of June (Cat. 55).

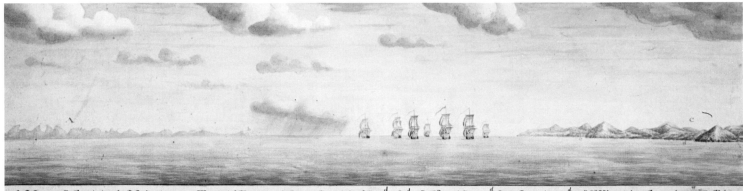

A View of Streight le Maire between Terra del Fuego, and Staten Land, in ỹ Lat: of 54:45 S?, and Long: from London 70:04 W!, with a Squadron of Ships under ỹ Command of Commodore GEO: ANSON Esq!. A. Part of Staten Land. b. Cape S! Bartholomew. C. Part of Terra del Fuego. d. Pt S! Maurice. e. by some taken for ỹ Bay of good Success, by others for Valentines Bay. We Steer'd thro' ỹ Streights S?, within three Leag? of Terra del Fuego, and found a very rapid Current set to ỹ Southward, till past ỹ Streights, then it set to ỹ Eastward along Staten-land, agreeable to Monf! Frefier's account. We had soundings from 55 to 85 fathoms, small Stones and shells between two and three Leag? from Terra del Fuego. Variation of ỹ Compass 22:30 Easterly.

2 Peircy Brett *The West Prospect of Staten Island . . . A View of Streight le Maire . . .*, early 1740s. Cat. 17.

As Commodore George Anson's second lieutenant on the *Centurion*, Brett sailed around the world between 1740 and 1744. His accomplished drawings, which were engraved for the published account of the voyage, illustrate the typical concerns of naval officers in making such drawings, not only the precise delineation of landfall, but also the weather conditions; note the rain shower to the left of the ships.

1672/3 of Willem van de Velde the Elder and his son Willem van de Velde the Younger. But there is evidence that one or both had visited England in the 1660s; 1672/3, a time of political uncertainty in Holland, marks their decision to settle in England. The Van de Veldes brought with them a firmly established tradition of marine painting, which had its origins in the Netherlands almost one hundred years earlier. The marine paintings of Pieter Brueghel the Elder are considered the earliest of their kind, and the etchings after his drawings by Jeronimus Cock and Franz Huys are among the earliest consistent portrayals of particular ships and ship types—they might almost be described as ship portraits.

In the first decade of the seventeenth century the Netherlands' struggle with Spain brought a demand for historical marine paintings depicting naval battles (such as Heemskerk's defeat of the Spanish off Gibraltar in 1607). In England marine paintings were known and collected to a limited extent at this time.[4] Works by Netherlandish marine painters such as Hendrik Cornelisz Vroom[5] can be associated with the Jacobean court, in particular depictions of the Spanish Armada, the marriage of Princess Elizabeth to the Elector Palatine in 1613, and the voyage of Prince Charles to Spain in 1623.

The military engineer and draughtsman Thomas Phillips was perhaps the first native British draughtsman to concern himself with the drawing of ships and naval battles. He worked in the tradition of Wenzel Hollar, who had come to England from Bohemia in 1637. Although not strictly a marine draughtsman, Hollar produced a considerable number of etched marine subjects (some of them detailed studies of shipping). His significance lies in his influence on certain native artists who stand on the periphery of marine draughtsmanship in its true sense.

Phillips's main official concern was with fortifications, and for this reason he went to the Channel Islands, 1679–80 (Plate 3). In 1683–4, with Samuel Pepys, he accompanied the Earl of Dartmouth as third lieutenant under Major Martin Beckman to Tangier to demolish the defences.[6] It is possible that paintings[7] as well as drawings and engravings resulted.[8]

In July 1677 Phillips, described as a 'designer of sea battles . . . some time employed by his Majesty in the drawing and designing of battles at sea', unsuccessfully petitioned Charles II for a pension, 'grounding the same upon what his Majesty has done by the two Van de Veldes, the Dutch painters, upon account of their sea-ships'.[9] Drawings by Phillips at Greenwich depict the battles of Solebay (1672) and the Texel (1673), subjects also drawn by the Van de Veldes. A further drawing by Phillips at Greenwich, a plan of the battle of Solebay, is inscribed in the hand of the younger Van de Velde *1672 felips*, suggesting the possibility of a closer connection

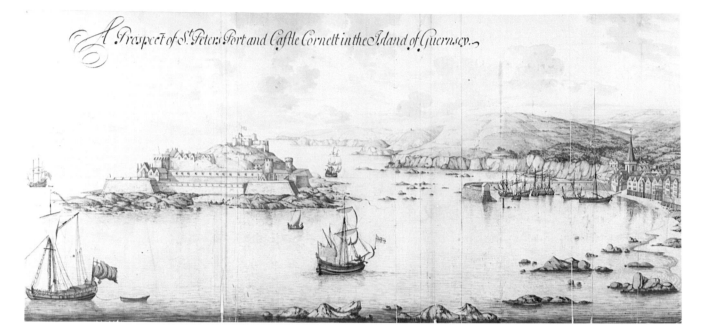

A Prospect of St. Peters Port and Castle Cornett in the Island of Guernsey.

with the Dutch artists. With an engineer's discipline Phillips interested himself in the detail of ship construction, and Pepys himself recounts: 'Mr Phillips tells me he will show me a draught of his of a ship furnished with all things whatsoever of any kind that belong to a ship of war.'[10] Possibly this drawing relates to the engraved 'section of a first rate ship' by Phillips; a painting also exists of this subject,[11] strengthening the suggestion that Phillips could paint.

The antiquary George Vertue mentions that the marine painter Isaac Sailmaker, a compatriot and almost exact contemporary of the younger Van de Velde,

> . . . came very young into England . . . [and was] imployed to paint for Oliver Cromwell a prospect of the Fleet before Mardyke when it was taken in 1657 . . . This little man imploy'd himself always in painting views small and great of many Sea Ports and Shipps, he was a constant labourer in that way tho' not very excellent. his contemporaries the Van der Veldes were too mightly for him to cope with. but he outlived them & painted to his last.[12]

Although Sailmaker's work was engraved, drawings by him are not known. His coastal views are a reminder of the close links in the latter part of the seventeenth century between marine painting and topographical art as practised by most visitors from the Continent.

In Holland the Van de Veldes, but in particular the Elder, stood apart from their contemporaries for the detailed and documentary quality of their draughtsmanship. Although the Dutch marine painter Simon de Vlieger also produced occasional portraits of individual ships, for the elder Van de Velde the drawing of 'ship portraits' was a constant concern, evidence of which are the hundreds of drawings of ships' hulls in the Greenwich and other collections (see Plate 5). As a genre it survived and developed over two centuries, adopted by the English artists of the eighteenth century and by printers and lithographers in the nineteenth.

During the 1640s and 1650s the elder Van de Velde, working independently and then as 'draughtsman to the fleet', recorded the movements and appearance of the merchant and naval fleets respectively, sometimes developing the drawings into *penschilderij*, the pen paintings (in England somewhat inaccurately referred to as *grisailles*) of which he was the great exponent in Holland. These activities inevitably involved him in physical danger, as when in August 1653 he was present in his galliot making drawings during the battle of Scheveningen.

Later in the century there is evidence in England of the authorities' need to employ artists to record ships and battles, as is indicated by the intriguing offer apparently made to the topographical draughtsman Francis Place during the reign of Charles II to draw the Royal

3 Thomas Phillips *A Prospect of St. Peter's Port and Castle Cornett in the Island of Guernsey*, 1680. Cat. 7.

Whatever the precise nature of the work carried out by Phillips for Charles II, it is clear that he had a thorough knowledge of the working of ships and an ability to draw them. Although the main concern of the Channel Islands' survey was with defences and landing places, the ships, for instance the yacht on the left and the naval vessel in the centre, are well drawn and in correct perspective.

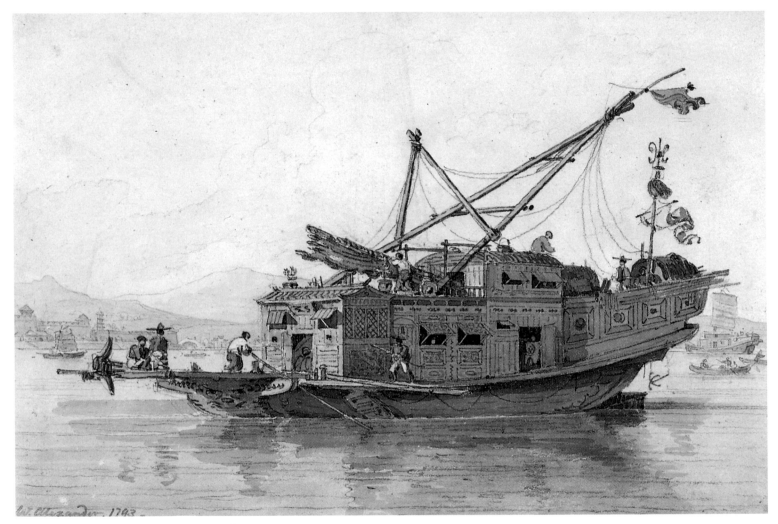

5 William Alexander *A Pleasure Junk*, 1793. Cat. 46.

Alexander went to China as a draughtsman attached to Lord
Macartney's embassy of 1792. Two years later Alexander returned with
many sketches, some of which were used to illustrate Sir George
Staunton's account of the embassy (1794) and Sir John Barrow's *Travels
in China* (1804). Local Chinese craft and their inhabitants were a frequent
subject.

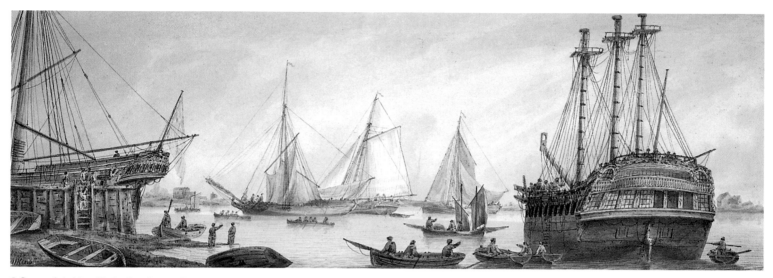

6 Samuel Atkins *Under Repair—an East Indiaman Drawn up for Repairs in a Busy Yard*, c.1790. Cat. 40.

Although Atkins's life is not documented, the works he exhibited at the Royal Academy between 1787 and 1808 and a period spent away at sea in the East (1796–1804) suggest a connection with the East India Company. His watercolours of shipping include a number of views of shipyards, such as this one on the Thames probably at or near Blackwall. An East Indiaman, still afloat, is being repaired. A similar vessel is drawn out of the water on the left and in the background are two large cutters.

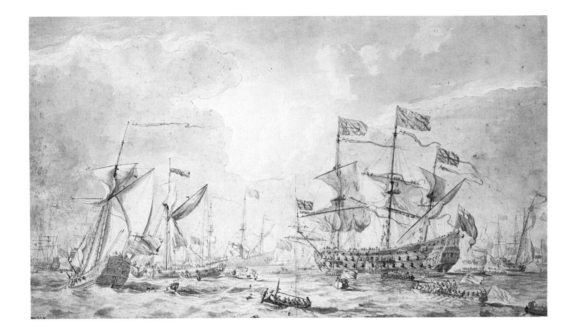

4 (*left*) Dominic Serres and ?Willem van de Velde the Younger *Charles II's Visit to the Combined French and English Fleets in the Thames*, probably 5 June 1672, 1785. Cat. 37.

An inscription verso by John Thomas Serres states that his father drew this in 1785. The earlier drawing, perhaps by Van de Velde, has been considerably worked up by Dominic Serres, by whom, it may be assumed, the paper on which the sky is drawn, has been pieced in. Dominic Serres is known to have owned Van de Velde drawings and there are others in the Greenwich Collections worked up in his hand.

5 (*right*) Willem van de Velde the Elder *Portrait of the Mordaunt*, ?1681. Cat. 6.

This drawing of a ship is more vigorous than the majority of the ships' hulls drawn by Van de Velde. As the drawing has been rubbed on the back, it is probably an offset from another drawing subsequently worked up in graphite and wash, a common practice of both the Van de Veldes. The *Mordaunt*, an English ship of 46 guns, was bought from Lord Mordaunt in 1683 and was wrecked in 1693. She is seen from astern, slightly on the starboard lee quarter, in a quartering breeze under fore and main topsails, fore course and main course half clewed up.

Navy for five hundred pounds a year. (Place, however, 'declined accepting it as he could not endure confinement or dependence'.)[13] No doubt this offer was stimulated by a period of growth in the navy, coupled with the renewed threat of aggression from Holland, which created an increased need for information. Some of the earliest examples of dockyard models of warships date from this period.

The royal warrant of 12 January 1674 under which Charles II employed the Van de Veldes is interesting because it specifies the distinct roles of father and son, one hundred pounds (paid by the Treasurer of the Navy) granted to the Elder 'for taking and making Draughts of seafights', and the same sum to the Younger 'for putting the said Draughts into Colours for our particular use'.[14] In general terms the wording of the warrant summarizes the studio practice of the Van de Veldes. Nevertheless a number of English period oil paintings by the Elder exist, rather stiff ship portraits and bird's-eye views of battles curiously lacking in vitality and inventiveness when compared with the *penschilderij* produced in Holland in the 1650s. There can be no doubt that drawings, particularly of ships' hulls, by both the Elder and the Younger, were a vital tool in the production of paintings. The relationship of the Elder's to the Younger's drawings, and of drawings to paintings, may now seem complicated, particularly with the additional use of offset as a means of transfer. Towards 1700, however, there is a noticeable loosening in the Younger's drawings style, which became more rapid and gestural, while retaining technical accuracy. During the years spent in England, the Younger exploited the full potential of the marine oil painting perhaps more successfully than his contemporaries remaining in Holland. This was to be the heritage of the English marine painters of the eighteenth century.

One way in which the compositions of the younger Van de Velde were disseminated in the early eighteenth century was through engravings. The set of mezzotints engraved by Elisha Kirkall and 'printed in sea-green' appear to have been popular, Vertue recording 'the twelve mezzotint plates after Van de Veldes sea peces by that he gained much—a M. pound—or near it'.[15] A significant number of pictures by British marine painters can be traced to this source during the early and middle years of the eighteenth century.

The collecting of Van de Velde drawings was also widespread. They entered the collections not only of marine artists such as Samuel Scott (there were several hundred in the 1773 Scott sale[16]) and Dominic Serres, but of others including Paul Sandby (Plate 16), Joshua Reynolds and J. M. W. Turner. Some must certainly have reverted to their original use as studio aids, particularly helpful for the technical problems of ship construction and rigging.

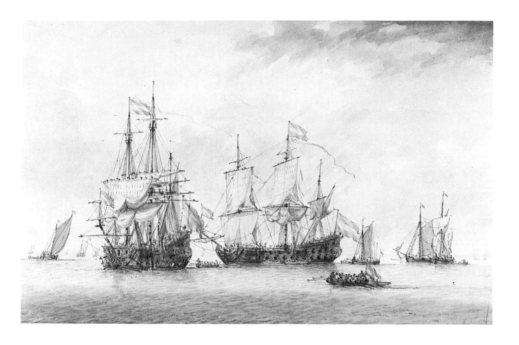

To the complex problems of assessing a vast body of Van de Velde drawings is added the problem of additions, sometimes considerable, by artist-owners. In some may be recognized the hand of Dominic Serres (Plate 4) but the main culprit was the gentleman-amateur Charles Gore who in his own right 'as a draughtsman has been undeservedly but understandably neglected'.[17] Gore, who was also a skilled amateur marine architect and yachtsman, reworked slight Van de Velde drawings in varying degrees, presumably for his own amusement, to the point where they become unrecognizable and difficult to catalogue as Van de Velde. In addition he made copies as well as independent Van de Velde-like drawings of seventeenth-century shipping (Plate 6). His views of contemporary shipping are among the most accomplished marine drawings of the eighteenth century—a number of them dating from a visit to Sicily with Richard Payne Knight in 1777 in the company of the German painter Phillip Hackert.[18] He is included in Johann Zoffany's portrait of Earl Cowper and family, playing the cello; near him on a chair are spread some marine drawings, presumably either his own or Van de Velde's.[19]

It has been observed that the 'Van de Veldes, and especially the younger artist, are at once the glory and the bane of English marine art. Their very excellence set a standard which none of their successors have rivalled but which may have attempted to repeat.'[20] That none of the marine artists of the eighteenth century could rival the Van de Veldes may be disputed; that they were imitated is certain, and they continued to influence not only marine artists of the following generation, but artists of the next one hundred and fifty years.

The decades immediately after the death of the Younger in 1707 were indeed marked by dependence on the Van de Velde model, if not sheer repetition. The extent to which the tradition was carried on by the remaining members of the studio and family is unclear. The London-born Peter Monamy was the most successful exponent, though not innovative—consolidating and using the Van de Velde pattern, and of no particular note as a draughtsman. By the middle of the eighteenth century, however, marine painting was emerging as a peculiarly English phenomenon:

> Marine painting in Vandervelt's taste is a branch of the art in which one need not be afraid to affirm that the English excel. And yet we must not imagine that there are a great number of able artists in this, any more than in the other branches. But when one or two hands become as eminent, as those who are now distinguished for marine pictures in England, are not they capable of giving a character of superiority to their

6 ?Willem van de Velde the Younger and Charles Gore *Two Dutch Flagships*, early 1780s. Cat. 28.

Where anachronistic details in shipping may enable Gore's reworked Van de Velde drawings to be distinguished, equally the existence of certain subjects by Van de Velde may shed new light on drawings hitherto considered to be independent studies of seventeenth-century shipping by Gore.

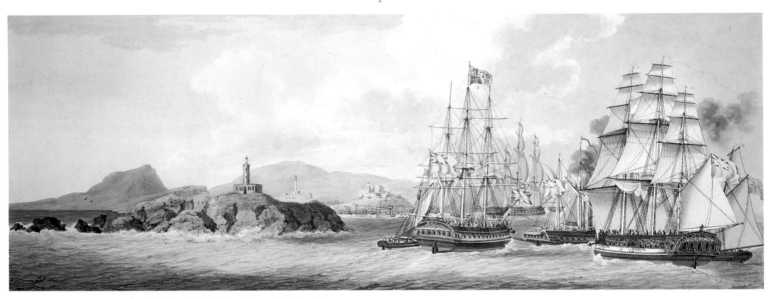

7 John Thomas Serres *The Arrival of His Majesty George the Fourth in Scotland, Accompanied by the Royal Flotilla, August 1822.* Cat. 84.

In 1793 John Thomas Serres succeeded his father Dominic as Marine Painter to George III. He was also appointed Marine Draughtsman to the Admiralty. However, his career was ruined by a disastrous marriage which lost him royal favour and plunged him into debt. To escape his wife's creditors he fled to Edinburgh in 1818. This watercolour would suggest that he was among the artists, including J. M. W. Turner, who were present at George IV's arrival in Scotland four years later, but it is possible that Serres was incarcerated at the time.

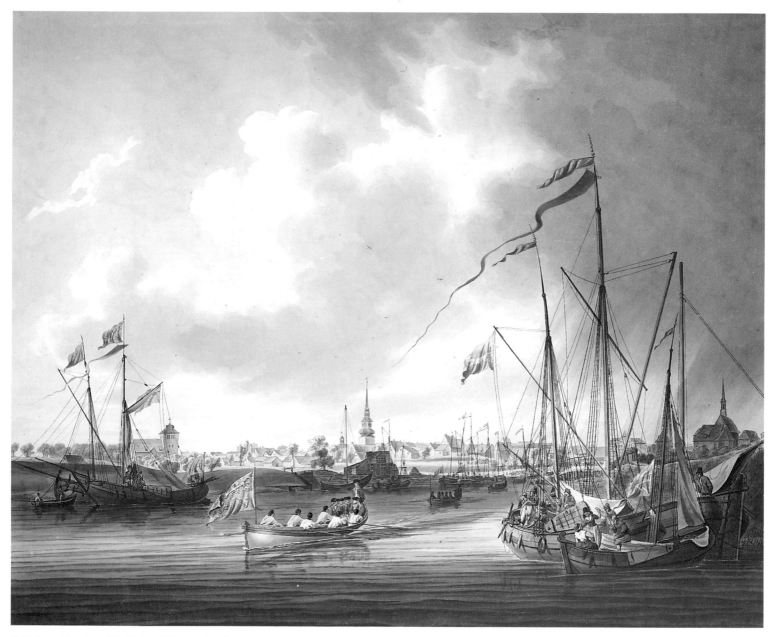

8 Robert Cleveley *The Duke of Clarence Landing at Stade, Prussia, 1 August 1783*. Cat. 35.

During a break in his naval service, Prince William (created Duke of Clarence in 1789) was sent on the Grand Tour by his parents George III and Queen Charlotte. On 31 July 1783 he departed from Greenwich; 'About half-after twelve, the Prince embarked on board the Princess Augusta Yacht, Captain George Vandeput, which fell down the river the same tide; and, on the 1st of August, arrived at Stadt, where his Royal Highness was waited upon by the Regency and citizens, with every mark of respect.' As Vandeput's clerk, Cleveley was probably present. Another watercolour by Cleveley of the Prince's arrival at Greenwich is in the collection of the National Maritime Museum.

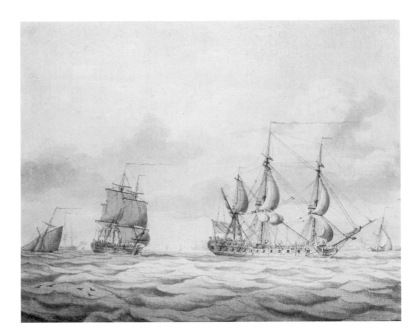

7 Charles Brooking *Two Frigates before the Wind*. Cat. 19.

It is likely that Brooking's detailed knowledge of shipping, in particular of naval ships (which account for a large proportion of his subjects), originated in his association with the naval dockyard at Deptford. This is not to suggest that his work was comparable with the ship portrait painters, for his compositions are invariably fresh and original, his observation of shipping, sea, sky and weather perfectly balanced.

country. Everything that relates to navigation is so well known in England, and so interesting to that nation, that it is not at all surprising to see them greatly pleased with marine pictures.[21]

The 'one or two hands' referred to were probably Samuel Scott and Charles Brooking, both active in London in the 1750s. As a marine painter in the Van de Velde tradition, Scott produced paintings of naval actions, ships in stormy seas and calms as Monamy had done. In Brooking, on the other hand, there is a freshness, a reappraisal of subject, and to a large extent a freeing from the Van de Velde stereotype. His drawings as well as his paintings reveal extraordinary observation of sea and weather as well as shipping, conveying a strong sense of the first hand and of locale. Even his pictures of naval engagements have an originality of composition, sometimes with unusually atmospheric effects (Plates 7, 8). None of his immediate followers, even Dominic Serres and Richard Paton,[22] despite their greater prominence, gave their subjects the same degree of lyricism as Brooking.

The foundation of the Royal Academy in 1769 provided a forum in which marine painting might be exhibited and assessed alongside other kinds of painting. Among the thirty-six founder members, however, there was only one marine painter, the Gascon Dominic Serres who shared minority status with flower painters (two) and animal painters (one). Serres was comparatively newly arrived in the country[23] and is reputed to have been associated with Brooking.

An affinity with the work of Brooking was apparent. Of the two paintings by Serres exhibited in 1780, both of recent naval engagements, it was noted that they 'are very capital paintings; the events represented in them are rendered highly interesting: the shipping very highly finished and the sea expressed with that accuracy of colouring, which distinguishes the works of *Brooken* [*sic*] and *Monamy*'.[24]

The pictures exhibited by Serres at the Royal Academy two years earlier, in 1778, had also received enthusiastic praise for their historical accuracy:

The subjects are so well described, that we even fancy ourselves anchored on the spot. The shipping are exceedingly correct, and so far as one can judge from accounts of the engagement, the manoeuvres are strictly represented. This Artist is always fortunate in his subjects, and there never was one which deserved more to be transmitted by his pencil, to posterity, than the present.[25]

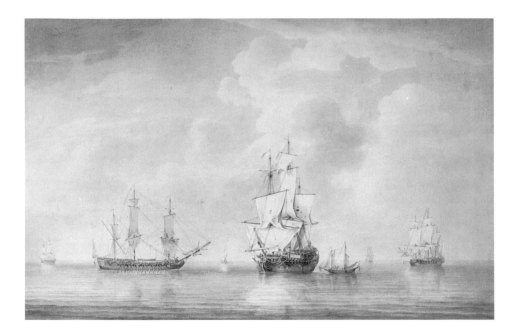

Not all critics, however, were so favourable:

> I would rather be knighted and like Sir John Falstaff, drinking a cup of good sack, than have occasion to give my opinion on this performance, which never from beginning to end transported me in the least by its fire, vivacity or brilliant appearance, it is rather tame in all its parts; but had it been attended by the complete Victory, it would have been admirable, and no true Englishman would bar ringing a ton of bells on the occasion.[26]

As an addition to current naval actions, the monarch and his family provided a range of subjects for the marine artist. Visits to the fleet and reviews provided subjects for compositions on the grand scale which could be exhibited. The 1773 review of the fleet at Spithead by George III provided subjects for pictures at the Royal Academy in 1774 by Francis Holman and John Cleveley the Younger as well as Serres. During the 1780s Robert Cleveley, marine painter to the Duke of York, as well as marine draughtsman to the Duke of Clarence, produced watercolours associated with various visits made by the latter, third son of George III (Colour Plate 8). Charles II had set the fashion for pleasure sailing, and during the Hanoverian period in particular there were numerous Channel crossings usually on the way to and from family and lands in Germany, as well as royal progresses such as those made by George IV to Ireland in 1821 and to Scotland in 1822 (Colour Plate 7). At the very beginning of George III's reign the long and stormy voyage of his bride from the Continent became the subject for a number of marine painters, among them Serres (Plate 9). The King and his family also sailed for pleasure on board the *Augusta* yacht.[27]

Although it was not until 1791, two years before his death, that Serres became Marine Painter to the King, for the previous two decades he appears to have been pre-eminent among marine painters, exhibiting at the Royal Academy more consistently than any other. In 1783 his neighbour and friend Paul Sandby referred to Serres as being 'at the head of naval affairs'.[28] In his dealings with the Academy Serres typified the marine artist. On 4 June 1774 he arranged a salute during a Royal Academy banquet:

> Of the surprises the most startling was a salute from the river of twenty-one guns when Sir Joshua proposed the first toast—the health of His Majesty. The salute was from the guns of a small armed ship which had been brought up the Thames for the purpose and moored off Somerset House. This part of the entertainment was

8 Charles Brooking *The Taking of the Nuestra Señora de los Remedios . . . , 5 February 1746.* Cat. 18.

Engraved by Boydell in 1753, this drawing depicts the taking of *Nuestra Señora de los Remedios*, a Spanish ship 'very Richly Laden', by three of the 'Royal Family' privateers on 5 February 1746. A companion plate, also after Brooking, shows the wreck of the same vessel off Beachy Head on 29 November following.

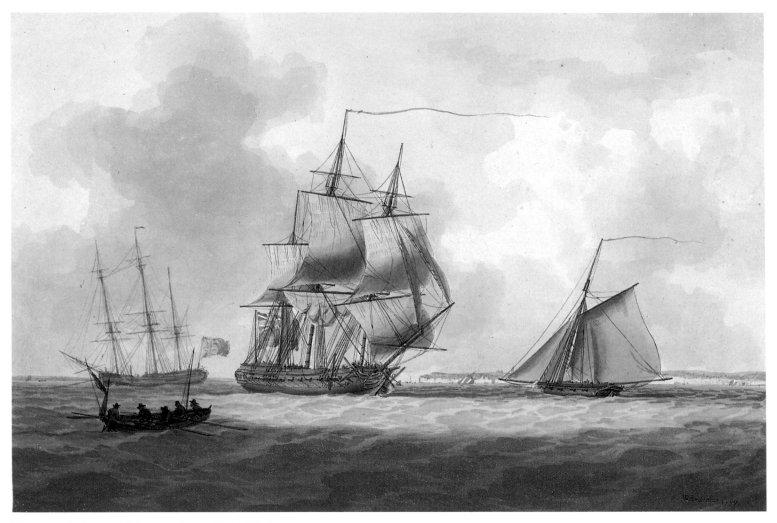

9 William Anderson *A Frigate Awaiting a Pilot*, 1797. Cat. 58.

After working as a shipwright in Scotland, Anderson settled in London
and established himself as a marine painter. From 1787 he exhibited oil
paintings and watercolours at the Royal Academy. Although he
continued to exhibit until 1834, his style belongs to the eighteenth
century. His views of shipping are particularly close to those of Brooking
and Dominic Serres.

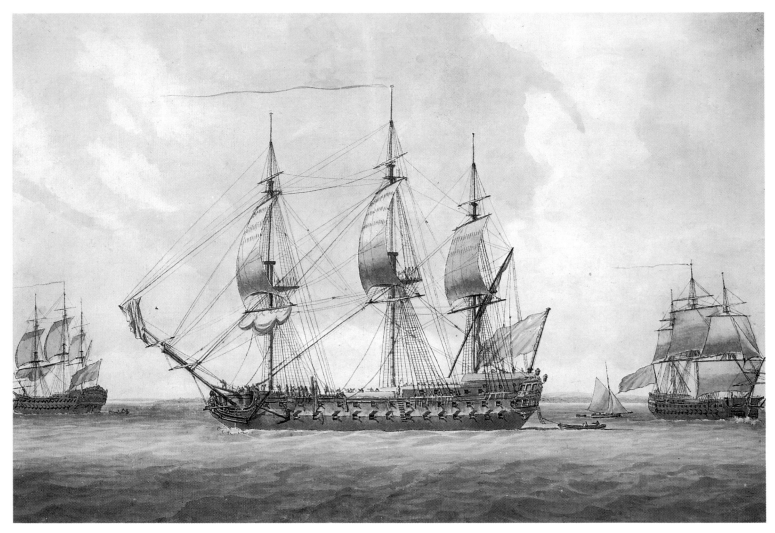

10 Dominic Serres *A 74-gun Ship in the Solent*, c.1788. Cat. 42.

This late drawing by Serres is a typical 'ship portrait', depicting in detail a particular vessel, possibly in connection with a commission. Serres adopts the current convention of showing the same ship in three different positions. The name of the vessel is not known, but she is of somewhat antiquated build, dating from around 1760.

directed by one of the Academicians, the Gascon, Dominic Serres, who is described by a contemporary artist as 'a fine boisterous fellow', well versed in Latin, Italian, Spanish, French and Portuguese, and speaking fluent English. Serres, as he had been a sailor in his youth and now painted pictures of naval battles for the King, was supposed to be an authority on the subject of salutes.[29]

Although it may be misleading to assume that the title 'marine painter' or 'marine draughtsman' to the monarch was necessarily of great significance,[30] such patronage was keenly sought—particularly, it would seem, by John Thomas Serres, who on his father's death in 1793 inherited or assumed the title. The publication line of the *Liber Nauticus* (1805) describes the younger Serres as 'Marine Painter to HIS MAJESTY, His Royal Highness the DUKE OF CLARENCE,/And Marine Draught-Man to the Honourable the BOARD OF ADMIRALTY', the latter being a more lucrative post.[31]

The Board of Admiralty did in fact, though unwittingly, provide some of the most imaginative patronage of the century, when in the 1770s it appointed professional artists to accompany Captain Cook's second and third voyages. In June 1772 William Hodges, a landscape painter and pupil of Richard Wilson, was 'engaged to proceed out in the *Resolution* to make Drawings and Paintings of such Places as they may touch at worth notice, in their intended Voyage'.[32] The resulting paintings and drawings, but particularly those actually produced on the voyage, are among the most startlingly direct images of the period, depicting, often at first hand, the islands of the South Pacific, New Zealand and Antarctic regions. Hodges's drawings (Plate 1), no less unconventional than his voyage paintings, are remarkable for their broad handling and rendering of observed natural effects. John Webber's precise tinted drawings (Plate 10), conventional in contrast to Hodges, represent outstanding ethnographic records of the places visited on Captain Cook's third and last voyage.

The advice and instruction regarding the drawing of craft and types of sea offered by the younger Serres in the *Liber Nauticus* did not extend to the special problems of the use of the watercolour medium. Nicholas Pocock, however, provides in a letter of 1804 some insight into contemporary, or at least his own, practice:

> I have inclos'd a Sketch of Scales of tones produced with 3 Colours only which are sufficient to produce any colour or effect whatever—the Sketch of boats is done as follows—the Cloud first with light red and blue only, the Water the Same with a little blue added to it, the Same pencil just touch'd on the yellow oker for nearest

wave, the near vessell blue and red, with rather more red than in the sky it is the most Aerial tint, and any colouring may be wrought upon it, with great Clearness and force . . .[33]

The war with France, 1789–1815, helped to stimulate an unprecedented market for an increasing number of marine painters and draughtsmen of varying abilities, often throwing them into closer contact with their patrons. A marine artist might commonly find his patron keen to involve himself in the minutest matters concerning the composition. Plans and rough sketches of an action might well be exchanged. The sketches and letters of Nicholas Pocock illustrate this; for example: '21st May 1812/ Mr Pocock has left the Note to Captain Hotham open in hopes Lady Edmonstone will have the goodness to look over Mr P[ocock's] remarks on the point of View previous to forwarding it to Capn Hotham.' The sheet is further annotated *Approved. W Hotham*.[34] Not surprisingly the imposition of such stringent discipline upon the artist might, to the more general viewer, result in dullness, a criticism frequently levied against pictures of naval battles. The concern for correct detail at the expense of artistic quality is particularly marked in the works of Thomas Buttersworth, himself a seaman, who repetitiously produced large colourful watercolours of the actions of the war. These, no doubt, gave considerable satisfaction to those naval gentlemen who owned them. One has only to examine the inventories of Thomas Luny,[35] one of the most successful painters of the period, to realize the high degree of repetition of subjects by marine painters at this time.

That such stickling for accuracy characterized the taste of naval officers had been observed some considerable time before, in the 1750s:

> It is become almost the fashion for a sea officer, to employ a painter to draw the picture of the ship which he commanded in an engagement, and where he came off with glory; this is a flattering monument, for which he pays with pleasure. The hero scrupulously directs the artist in every thing that relates to the situation of his vessel, as well in regard to those with whom, as to those against whom he fought. His politeness will not permit him to put any one out of his place; and this is a new point, of which the painter must take particular care. And indeed an error in arrangement, upon this occasion, might be taken as a very great incivility.[36]

The bluff Duke of Clarence (later King William IV) provides the interesting example of the royal patron who was also a typical naval officer, entering the navy as an able seaman and

10 John Webber *The Resolution and Adventure in Nootka Sound*, 1778. Cat. 32.

Having studied in Berne and Paris, Webber, the son of a Swiss sculptor, entered the Royal Academy Schools in 1775, but the next year sailed on Captain Cook's voyage to the South Seas. Many of his drawings were engraved for the Admiralty's account of the expedition published in 1784, and from 1792 he worked on a series of aquatints of the places visited. This drawing, typically detailed and carefully drawn, depicts Nootka Sound on what is now Vancouver Island, where the ships anchored for a refit in April 1778. Observations were made, and the tents and instruments can be seen on a rock further round the cove.

11 John Sell Cotman *Study of Sea and Gulls*, 1832. Cat. 90.

Intimately acquainted with the sea and craft of his native East Anglian
coast, Cotman frequently made them the subjects of his watercolours.
Despite the strong blue colouring typical of his work in the 1830s, this
example is comparable in mood to his early marine subjects such as *Boat
on the Beach*, 1808 (Cat. 73).

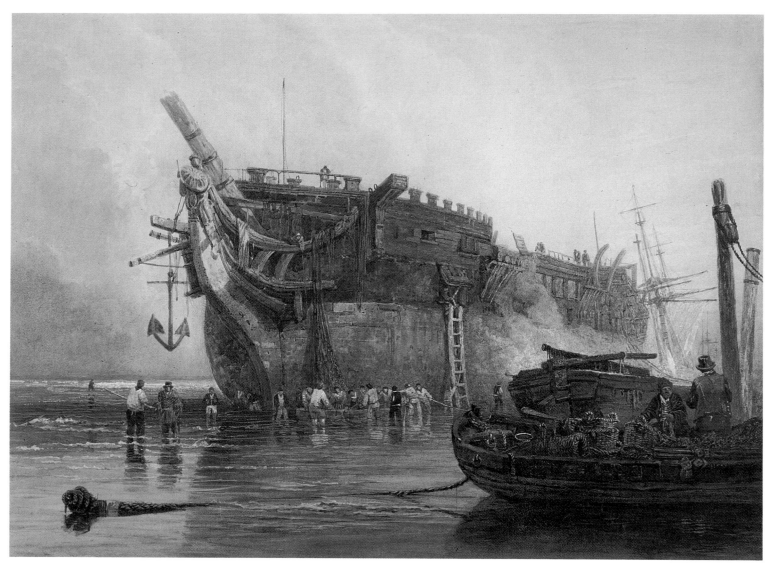

12 Samuel Prout *An East Indiaman Ashore*, c.1821. Cat. 78.

Prout, a native of Plymouth, witnessed the wreck of the East Indiaman
Dutton in Plymouth Sound in 1796. This early experience may be
reflected in the series of monumental watercolours of dismasted Indiamen
run aground, which he exhibited at the Society of Painters in Water-
colours in 1819, 1820, 1822, 1824, and 1831.

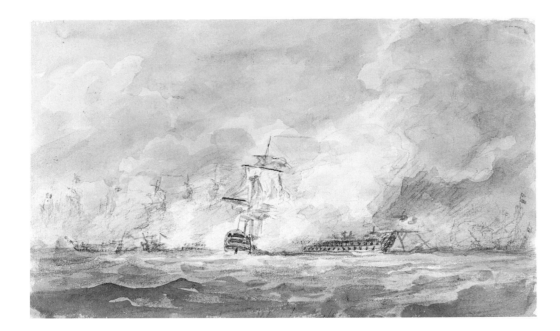

seeing active service during the 1780s. As an experienced seaman, the Duke's views on marine painting were very definite, as Turner learnt in 1824 while working on his large painting of the battle of Trafalgar which had been commissioned by George IV for St James's Palace.[37] Despite Turner's great pains over the picture, to the extent of obtaining sketches of particular ships from J. C. Schetky in Portsmouth,[38] the Duke, on inspecting it:

> . . . immediately began as a sailor to make his observations which not being agreeable, he says that Turner was rather rough in his reply. They went on for some time and the Duke finished the conversation by saying, 'I have been at sea the greater part of my life, Sir, you don't know who you're talking to, and I'll be damned if you know what you are talking about.[39]

The print market also flourished. The names of Robert Cleveley, Nicholas Pocock, Robert Dodd, Thomas Buttersworth, J. T. Serres, Thomas Luny and Thomas Whitcombe recur on naval prints of that period. Surprisingly few artists, however, were present at the actions of the war, the notable exception being Nicholas Pocock (Plate 11). The majority of images were therefore based on verbal or written accounts by officers present, or contemporary published accounts such as those provided by the *Naval Chronicle*. Sketches or plans by those present at the action might also be used as a framework for the artist.[40] It is instructive to note that the fifty aquatint plates which the publisher James Jenkins assembled in *The Naval Achievements of Great Britain from the year 1793–1817* are described as being 'from original drawings made by Officers who were in the actions represented', although in each case the artist's name is given as Thomas Whitcombe, one of the more skilled marine painters of the period.

John Christian Schetky, during his long tenure as Drawing Professor at the Royal Naval College at Portsmouth (1811–36), formed close links with generations of naval cadets whom he taught and who later as officers became his patrons. Writing in 1831 to his former pupil Captain George White, stationed in HMS *Melville* off the coast of Portugal, Schetky advised:

> No doubt you are sketching every day. Now let me advise you to make minute studies of every kind of boat of the country, and draw the inside of them as well as sheer and shape—ay, the inside, with all the gear you see in them—nets, crab-pots, spars, casks, sails, and everything, most carefully, marking the colours of each, and depend upon it you will find the good of it hereafter. What would not I give just now for a minute study of a Lisbon bean-code for my present picture! but I have it not,

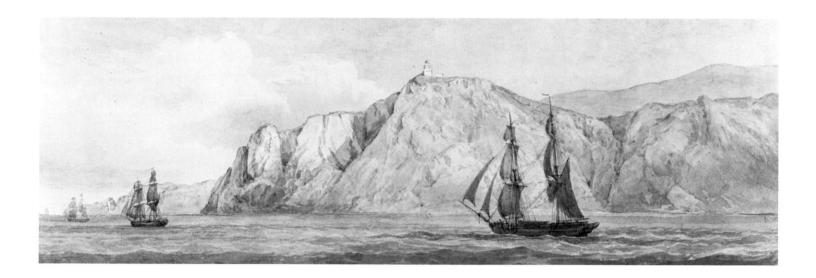

and therefore I am asking everybody about their style and character. Draw also, and colour, the pescatori and all sorts of boatmen, and always write under each sketch where they belong to, and above all, date them: it is mightly pleasant hereafter to know where you were on such a day—it is a sort of graphic log.[41]

In the years after the Napoleonic Wars, the emphasis, even the definition, of marine painting changed: it became much less specialized and more general in its subject matter. The apparent decline in the popularity of naval pictures was commented on not altogether impartially by Schetky in 1847 when he submitted a large painting of the battle of La Hogue to be considered as part of the decoration of the new Houses of Parliament:

> *No marine man* has any chance! Had there been among the judges some admirals or other sailors, these might have been a small ray of hope; but all is for *figures* in historical pictures, forgetting the safety and comfort of our firesides are attributable to the valour and indomitable courage of our naval heroes, who have ever kept the war—ay, every war—from our shores.[42]

Nevertheless there continued to be a market for pictures of naval battles from officers requiring a record of their service, often retrospectively.

A key place in nineteenth-century marine painting is held by George Chambers, who showed an ability to carry out major naval commissions, while at the same time absorbing and manifesting influences, particularly of his near-contemporary Bonington.[43] Chambers was advanced by the naval officer, Lord Mark Kerr, and some of his first patrons were naval officers. Of the picture of HMS *Hydra* at Bagur, 8 August 1806, one of two subjects painted for Admiral George Mundy and both engraved by Paul Gauci, the Admiral wrote:

> I approve of your drawing of the ship, of the sea and of the land; they are, in my humble opinion, pretty and very spirited: but I must object to the handling of the sails. Why is the foretopsail not set?—no man of war loosens her foretopsail as a signal for sailing—unless she is in charge of a convoy and at anchor. The jib should be eased a third in on the jib boom—it will look more ship-shape in blowing weather. The mizen or spanker need not be loose, which will shew an ensign at the mizen peak, which you should hoist, and blow upwards like your jack at the foretopmast head—these alterations be so good as to make, and then I will pronounce it perfect.[44]

12 John Christian Schetky *The Rock of Lisbon*, 1861. Cat. 130.

In the summer of 1861, at the age of eighty-two, Schetky made his last visit abroad. His two weeks' passage to Lisbon on board the steamer the *Alhambra* was a gift from the directors of the Peninsular and Oriental Steam Navigation Company. Schetky wrote of being 'up at five or six every morning, sketching everything along the picturesque shores of Spain and Portugal'. These were considered 'his best efforts in watercolours'. This example, delicate and extremely fresh, is strongly reminiscent of the coastal views in which Schetky himself had instructed naval cadets at Portsmouth earlier in the century.

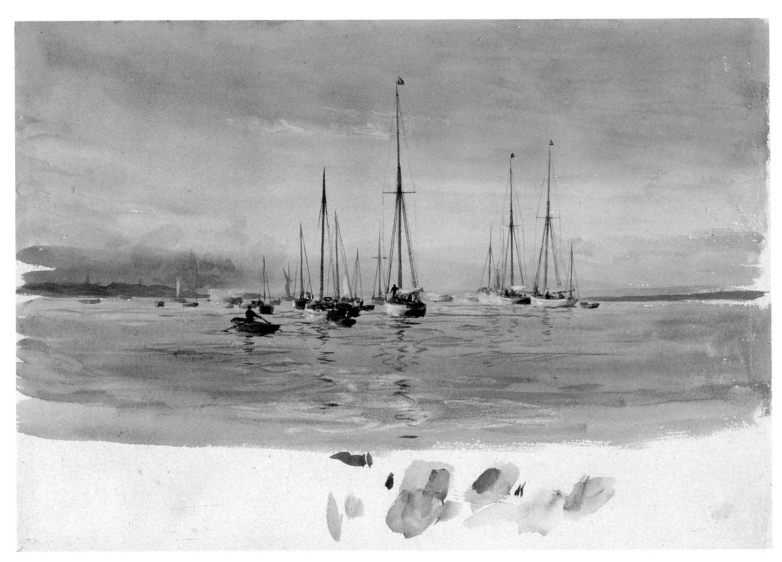

13 William Lionel Wyllie *Yachts at Anchor*, c.1900. Cat. 149.

Although Wyllie's watercolour exhibitions at the Fine Art Society and the Rembrandt Gallery during the 1880s and 1890s were generally received favourably, the informal studies he made outdoors in the years around 1900 demonstrated a considerable advance in his handling of the medium. His 'wet' technique of laying his colours into a soaked paper allowed him a freer expression. As his manual *Marine Painting in Watercolour* (1901) asserts: 'No drawing is ever so satisfactory as one that is completed at one painting . . .'

14 William Lionel Wyllie *Straits of Gibraltar*, c.1890. Cat. 146.

This watercolour, possibly from one of the frequent cruises taken by
Wyllie and his wife, is characteristic of those he made in the early 1890s,
before his adoption of a freer, more fluid watercolour technique. Spatial
and atmospheric effects are achieved with a restrained use of the medium
and a pale palette.

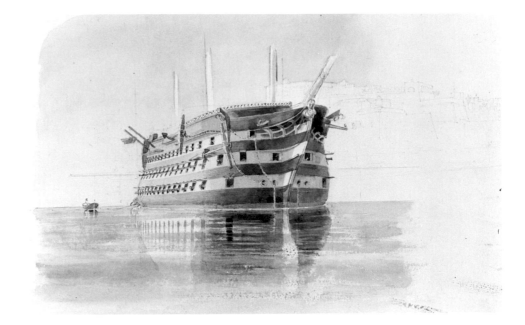

According to a published account William IV displayed the warm appreciation of an old sailor during an audience with Chambers arranged by Kerr in 1831:

> Chambers opened his portfolio of sketches, and turned them over to the King's view. 'Ah, very good, very good,' said William. 'I'll go and bring Adelaide—there is a good light here—she can see them here very well.' With that he walked away, and presently returned, leading the Queen, arm in arm. 'This is Mr Chambers,' he said—'he has brought his sketches for you to look at—I would like to see your choice.' Taking up a sketch of a storm-scene, he said, 'I would choose that!' The Queen replied—'I don't like that—it is too terrible.' 'Oh, ma'am,' he said, with a smile—'we sailors like such subjects best—eh, Mr Chambers?' However, the Queen chose a view of Dover, and another of Greenwich, marking the sketches with a pencil.[45]

Despite adverse criticism by the naval fraternity at Greenwich of the large bombardment of Algiers painted for Greenwich Hospital in 1836,[46] a newspaper critic, commenting on some other works of Chambers, noted that 'the shipping appears to be minute and correct . . . but the power which is displayed in representing with freedom and truth the natural effects of the scene, the sea and the distance display talents of a very high order.'[47]

Edward William Cooke, like Chambers, maintained a lifelong interest in the minutiae of all maritime objects, producing his series of etchings for *Shipping and Craft* in 1829 when only eighteen, and thereafter a constant flow of scientifically precise pencil drawings of ships and parts of ships. These were his reference source, and comparable with the thousands of small sketches made by W. L. Wyllie from the 1860s until the 1920s, a vast archive illustrating many aspects of maritime life.[48] Cooke's exhibited pictures were mainly of coastal subjects and his travels in France, Italy and in particular Holland were typical of artists of the period such as David Roberts and Edward Lear. It is interesting to note that, although one of the leading marine painters of his day, Cooke did not paint pictures of naval actions.

With the broadening appeal of marine painting as the nineteenth century progressed, it becomes increasingly difficult to identify those artists whose interests remained those of the specialist. The littoral painter might have as profound an interest in his subject as the 'deep sea' or the naval painter. The growth in the mercantile trade encouraged the increasingly separate genus of the ship portrait artist, while the navy, under the instruction of artists such as Schetky, produced watercolour artists of a high quality.

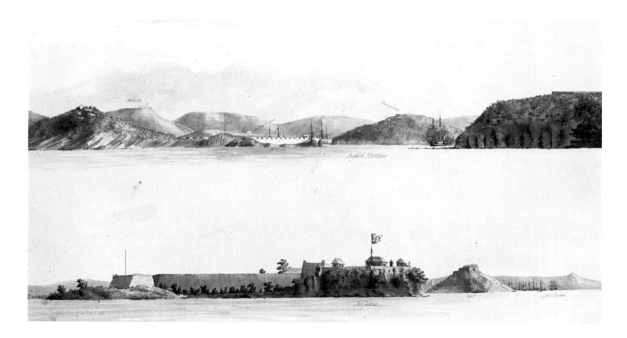

The sketchbooks of marine artists and naval officers, often remarkable for the fresh state of the preservation of their contents, may provide valuable evidence of working methods. The talented naval officer George Pechell Mends, in a sketchbook started in 1850 (Plate 13), specifies the particular pigments used:

COLOURS FOR THE SEA

Greys and First Washes: *Cobalt & light red French blue & lamp black*
 French blue & Brown madder Indigo & Indian red

Local tints *Cobalt and burnt Sienna* [sic] *Vandyke brown & Cobalt*
and Stormy Sea: *Vandyke brown & Indigo Raw Sienna* [sic] *& Indigo*
 Raw Sienna [sic] *& Sepia* etc.

The second half of the nineteenth century saw the publication of a number of manuals containing practical advice on the production of marine paintings and watercolours. Those by John Wilson Carmichael and W. L. Wyllie, however, are among the most helpful, encouraging a close study of the craft to be depicted.

There was an increasing tendency for the more specialist marine painters to turn towards illustration as a livelihood. The rise of the weekly magazines in the middle years of the century, in particular the *Illustrated London News* and the *Graphic*, provided opportunities for regular employment of this kind. In 1855 Carmichael was employed by the former to record at first hand the war in the Baltic, a subject which also occupied Oswald Walters Brierly in the production of lithographs. Wyllie, during his long involvement with the *Graphic*, illustrated a wide range of maritime subjects, visiting Egypt in 1882 to report on the recent bombardment of Alexandria.

During the 1890s Wyllie produced some of the finest marine watercolours of the period, technically superb yet atmospheric views on the Medway and on the north French coast. This was in marked contrast to the repetitive and debased work of such contemporaries as Thomas Bush Hardy whose late work typifies the decline of the marine watercolour at the end of the century. Although under the patronage of successive monarchs the marine painter could still find employment, in the years after 1900 marine painting as practised by Wyllie, Charles Dixon and their followers inclined increasingly towards illustration—a tendency confirmed by the requirements of the Great War, and one from which, it is difficult, even now, to discern recovery.

14 Edward Henry Columbine
*Entrance to English Harbour,
Antigua*, 1789. Cat. 64.

Drawn while on board HMS *Sybyl*, this watercolour comes from a volume of coastal views. Columbine's coastal views are exceptional, far above the standard of most naval officers. His watercolours in their own right perhaps reveal a knowledge of Pocock, and his topographical drawings are also of a high quality.

15 David Cox, Sr. *Entrance to Calais Harbour*, ?1827. Cat. 87.

Cox passed through Calais in 1826 and again in 1829, taking the
opportunity to renew his acquaintance with Louis Francia, a former
colleague from the short-lived Society of Associated Artists in Water-
Colours. The indistinct date on this watercolour probably reads 1827,
placing it early in the series of calm, light-filled views of the harbour and
coast at Calais, which Cox painted and exhibited through the early
1830s. Such compositions were undoubtedly inspired by similar works of
Francia and of Francia's noted pupil, R. P. Bonington.

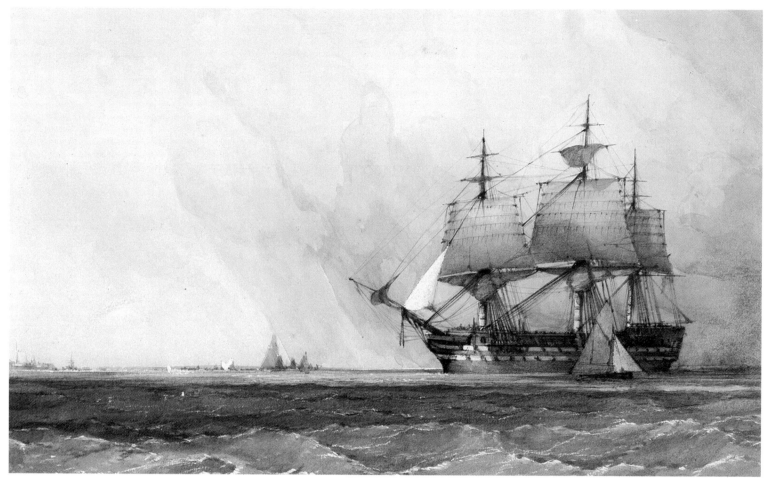

16 Charles Bentley *Coast Scene with Shipping*. Cat. 108.

Although apprenticed to the engraver Theodore Fielding, Bentley was influenced primarily by Bonington. This watercolour, depicting a naval three-decker, possibly in the Solent, confirms the extent of that stylistic debt.

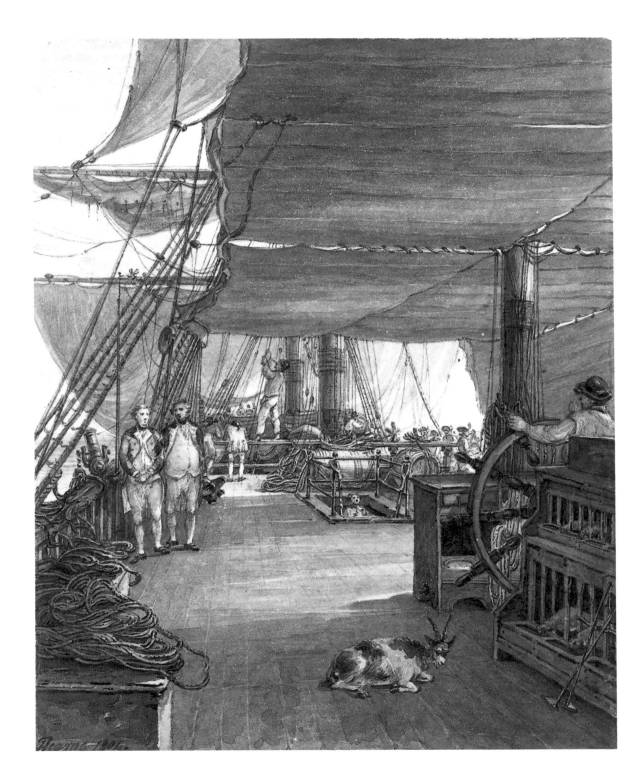

The Wider Sea: Marine Watercolours and Landscape Art

SCOTT WILCOX

Of all the works of the Creation none is so imposing as the Ocean; nor does Nature anywhere present a scene that is more exhilarating than a sea-beach, or one so replete with interesting material to fill the canvas of the Painter; the continual change and ever-varying aspect of its surface always suggesting the most impressive and agreeable sentiments—whether like the Poet he enjoys in solitude 'The wild music of the waves', or when more actively engaged he exercises his pencil amongst the busy haunts of the fishermen, or in the bustle and animation of the port or harbour.

This celebration of marine subject matter comes from the letterpress with which John Constable accompanied the mezzotint of *A Sea-Beach – Brighton* in the second edition of his *English Landscape Scenery*, published in 1833.[1] This type of subject matter never occupied more than a peripheral place in Constable's oeuvre, and his experience of Brighton was a good deal less positive than the letterpress would indicate. Thus an element of conventional aesthetic wisdom is discernible in the passage. Constable's need to include such sentiments in a work intended as an apology for his landscape art is one measure of how attitudes towards marine subjects in both oils and watercolours had changed from the previous century.

Marine painting in eighteenth-century Britain was, by and large, produced by specialists for an expert audience. It was essentially of a documentary nature, recording ships and naval engagements, harbours and coastlines. The marine watercolour of the period was the nautical equivalent, in both function and technique, of the topographical watercolour. That the marine draughtsman John Cleveley should have taken lessons from the eminent topographical watercolourist Paul Sandby underscores the connection.

The dramatic transformation that landscape watercolours underwent at the end of the eighteenth century and the beginning of the nineteenth—from topography to pure landscape and from techniques of drawing to those most suitably characterized as painting—was reflected in marine watercolours. New attitudes to the practice of watercolour coincided with a new conception of marine art—a recognition by artists with loftier pretensions than Brooking or the Cleveleys that the sea and man's life on the sea could be picturesque, sublime and potently symbolic. Stripped of the requirements to document particular vessels or naval actions, marine art could be appreciated and practised as a branch of, or an adjunct to, landscape painting, operating on the same general principles and playing its own particular role in the development of landscape and watercolour aesthetics.

15 Thomas Hearne *A Scene on Board HMS Deal Castle . . . on a Voyage from the West Indies . . . , 1775*, 1804. Cat. 66.

In 1771 Hearne accepted an offer from Sir Ralph Payne, recently appointed captain-general and governor-in-chief of the Leeward Islands, to accompany him as his official draughtsman. After three-and-a-half years in the islands, Payne was recalled and Hearne travelled with him back to England. It is likely that studies made on that homeward voyage formed the basis for this rare depiction of a shipboard scene.

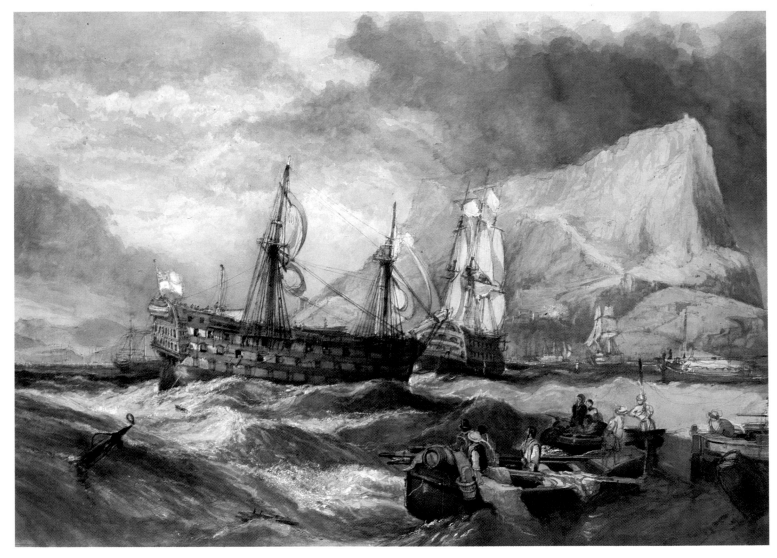

17 Clarkson Stanfield *HMS Victory Towed into Gibraltar, 28 October 1805,*
with the Body of Nelson on Board, 1853. Cat. 125.

This watercolour, with its loose handling and unfinished areas, is
probably a preparatory work for the large oil painting exhibited in the
Royal Academy in 1853, the second of Stanfield's Trafalgar pictures. It
shows HMS *Victory* towed into Gibraltar by HMS *Neptune* seven days
after the storm which swept many ships into the bay between Cadiz and
Trafalgar.

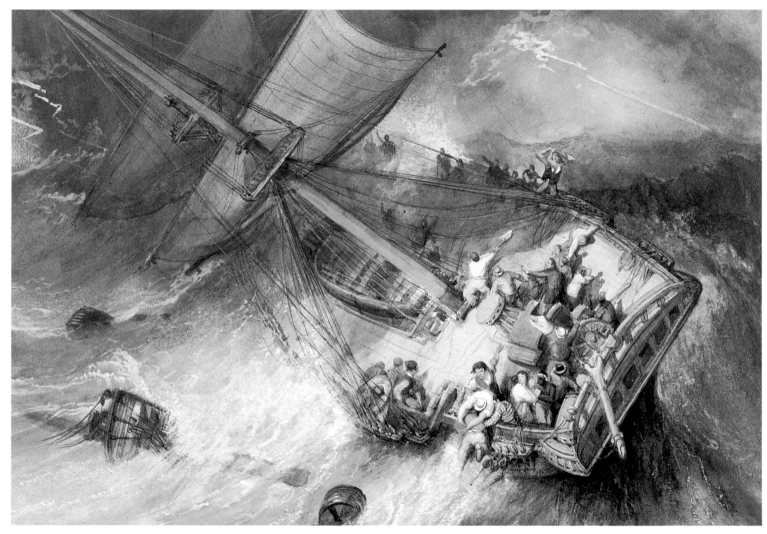

18 Clarkson Stanfield *Cutting Away the Masts*, c.1836. Cat. 97.

Engraved as an illustration to *The Pirate* by Stanfield's friend, Captain
Frederick Marryat, this watercolour represents the dramatic moment
when the masts of the *Circassian* are cut away in an attempt to save the
ship in a gale.

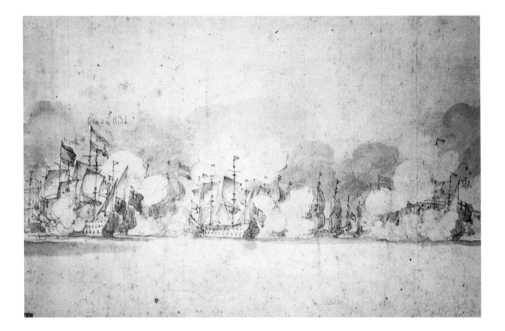

It is this shift in the perception of marine painting and of watercolour as a vehicle for such painting that is the primary concern of this essay, not the separating of marine specialists from non-specialists. For this very shift served to blur the distinction in the nineteenth century. The most renowned painters of marines of the period—J. M. W. Turner, Augustus Wall Callcott, Clarkson Stanfield and Anthony Van Dyck Copley Fielding—all encompassed a far broader range of subject than just the marine. Of these figures only Stanfield could be considered primarily a marine painter. Nicholas Pocock, a sea captain turned artist, known for his seascapes, devoted much of his artistic practice to picturesque topography. On the other hand, Louis Francia, who forged a significant link between the advanced English landscape watercolour and developments in France, regarded himself simply as a 'peintre de marines', the epitaph later inscribed on his tombstone.

Any account of the expansion of the audience for marine painting or of the adoption of marine painting by artists whose interests were not primarily nautical must begin, as must any account of the more narrowly defined marine tradition in Britain, with the Van de Veldes, father and son. Not only were these two artists acknowledged as the fount of British marine painting and, in the case of the younger Van de Velde, as the unsurpassed master of that tradition; as the appreciation of seventeenth-century Dutch naturalism grew in England in the eighteenth century, the Van de Veldes became valued as major representatives of that phenomenon. Thus an important link was established early on in English minds between the marine tradition and naturalism.

Although Sir Joshua Reynolds did not deign to treat marine painting in his series of discourses to the Royal Academy, he did, in the Third Discourse, link 'the Landscapes of Claude Lorraine, and the sea-views of Vandervelde' as examples of excellence in the lesser genres (here the reference is almost certainly to the younger Van de Velde).[2] Although he was rarely accorded equal status with Claude, the younger Van de Velde's niche as a marine specialist, while not lofty, was secure. For artists and connoisseurs, his works had value as masterly examples of painting and draughtsmanship with relevance to wider landscape concerns. A sheet bearing Paul Sandby's collector's stamp (Plate 16) testifies to the esteem in which his drawings were held by artists who were themselves not involved in sea painting.[3] Van de Velde was also represented in the collection of Dr Thomas Monro, whose so-called 'Academy' helped to shape the artistic education of a whole generation of watercolourists including Thomas Girtin, J. M. W. Turner and John Sell Cotman. When Turner remarked, on seeing a print after a Van de Velde marine, that 'this made me a painter',[4] he acknowledged

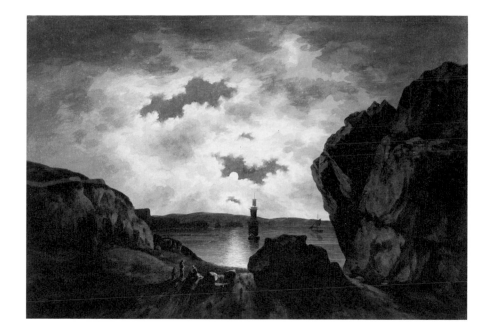

more than a personal artistic debt; he placed Van de Velde's marines in the mainstream of the great tradition of painting to which he himself was so conscious of belonging. Trained as a topographical draughtsman, but aspiring to be an oil painter of significance, Turner chose marine subjects for his early essays in the medium and looked to Van de Velde as a model.[5]

The individual achievements of the younger Van de Velde or of his fellow Dutch seascapist Ludolf Bakhuizen, as well as the rising tide of popular interest in Dutch art generally, would have ensured that British artists apart from marine specialists would take notice and seek to emulate Van de Velde's and Bakhuizen's art.[6] But the recognition of the seascape's potential as art also depended on developments outside the bounds of the visual arts. As Andrew Wilton has observed in *Turner and the Sublime*, the elevation of landscape painting from the 'local and trivial to the grand and universal' required a literary model, and that model was provided by James Thomson's *Seasons*, published between 1726 and 1730.[7] Thomson's four poems offered to landscapists not just episodes to illustrate but a new approach, a valuation of landscape as the seat and ground of all human activity. In his comprehensiveness, Thomson embraced the themes of maritime prosperity and the ever-present influence of the oceans on an island nation. He also incorporated into his poems several set pieces displaying the awesome natural power of the sea. Both *Summer* and *Winter* contain brief but dramatic accounts of storms at sea.

If Thomson's references to the sea pointed the way towards a conception of marine painting that saw as its proper scope the drama of man and the elements, another popular literary production from later in the century addressed itself exclusively to the subject of the sea. This was William Falconer's *The Shipwreck: A Poem*, which combined a seaman's specialized knowledge with the broader appeal of sublime and pathetic imagery—a combination particularly valuable to marine artists intent on transforming their genre into something of more universal import. Falconer had been the second mate on the merchant ship *Britannia*, whose wreck off the coast of Greece he recounted in heroic couplets. When *The Shipwreck* was first published in 1762, Falconer hoped to reach an audience of fellow seafarers. In an advertisement for the second edition in 1764, the author regretted 'that the gentlemen of the sea, for whose entertainment it was chiefly calculated, have hardly made one-tenth of the purchasers'.[8] But there were purchasers in plenty. Falconer had tapped a far wider audience, and by 1830 his volume had reached its twenty-fourth edition in English.

Nineteenth-century artists in search of literary sources for marine subjects were by no means limited to Thomson and Falconer. Coleridge's *The Rime of the Ancient Mariner* (1798), Cowper's *The Castaway* (1799) and the shipwreck episode from the second canto of Byron's *Don Juan*

17 John 'Warwick' Smith *Bay Scene in Moonlight*, 1787. Cat. 48.

In this striking night scene, Smith, known as one of the eighteenth century's innovators in watercolour painting, reproduced the type of moonlit coastal scene made popular in oils by Claude-Joseph Vernet.

19 Alfred Herbert *A Schooner and a Dutch Vessel Close-hauled in St. Helier's Bay, Jersey*, 1846. Cat. 106.

Herbert's coastal and fishing subjects usually show shipping in rough seas and windy conditions. His thorough knowledge of shipping, evident in this view off the coast of Jersey, may be traced to his background as the son of a Thames waterman and his apprenticeship to a boatbuilder.

20 Edward William Cooke *Hay Barge and Men-of-war on the Medway*, 1833.
 Cat. 92.

In Cooke's notebook (no. 36) this subject bears the full title: 'Hayboat,
Chatham—and men of war—with Rainbow and stormy effect—5th July.'
The watercolour resulted from a sketching tour in the Medway in 1833
with James Stark, a family friend and a member of the Norwich School.
Two years later, having received instruction in oil painting from Stark,
Cooke first exhibited paintings at the Royal Academy, one of them a
similar view of a hay barge, off Greenwich (National Maritime
Museum).

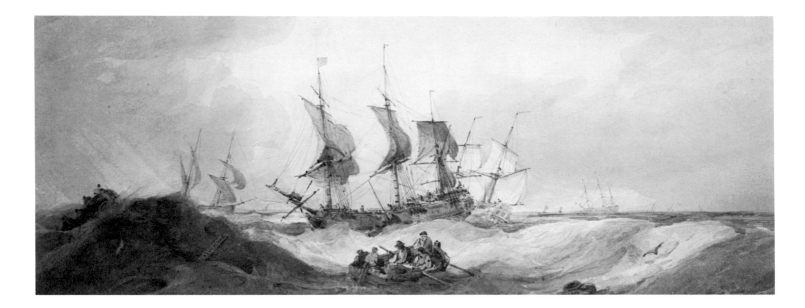

(1819) all turned marine disaster to poetic account. There were prose compilations such as James Stanier Clarke's *Naufragia, or Historical Memoirs of Shipwrecks, and of the Providential Deliverance of Vessels* (1805), which Clarke acknowledged as having been inspired by a painting of a shipwreck by George Romney.[9] There were as well a host of ephemeral literary productions celebrating British naval exploits during the Napoleonic period. Later in the nineteenth century one could add to this partial listing the popular marine novels of Captain Frederick Marryat. Stanfield's dramatic *Cutting Away the Masts* (Colour Plate 18) was engraved as an illustration to Marryat's *The Pirate*. But as the familiar and well-loved verses of Thomson continued to be a potent source of inspiration for visual artists well into the era of Wordsworth, so the conservative Thomson and Falconer exerted an ongoing influence over marine imagery. Pocock provided illustrations for two editions of *The Shipwreck* in 1804 and 1811. A drawing by the Victorian watercolourist Edward Duncan of a *Scene from Falconer's 'Shipwreck'* was included in the Fine Art Society's *The Sea Exhibition* of 1881.

Passages such as Thomson's description of a tropical typhoon or a Baltic gale, or Falconer's more circumstantial account of marine catastrophe, embody the eighteenth-century concept of the sublime. From its rhetorical and literary origins, the sublime came to be applied to the visible world and pictorial representations of it, embracing not just the realm of human action but the workings of nature in the landscape. Although the foremost systematizer of the aesthetics of the sublime, Edmund Burke, did not mention the sea or seascapes in his influential *Philosophical Enquiry into the Origin of Our Ideas of the Sublime and Beautiful* of 1757, it was easily inferred that the sea could provide prime instances of all the sublime characteristics enumerated by Burke. And if Burke had overlooked the sublime potential of the watery world, other aestheticians did not. For both Hugh Blair and Dugald Stewart, the idea of sublimity was inextricably linked with the immensity and force of the sea.[10]

While the sea was indisputably sublime, its pictorial representation was problematic. The Rev. William Gilpin, the arbiter of the Picturesque, put the problem succinctly: 'Nothing can be more sublime than the ocean; but wholly unaccompanied it has little of the picturesque.'[11] Attempts to represent the sea 'unaccompanied' were, of course, virtually unknown. The shipping which constituted the principal subject of the younger Van de Velde's art had significance for Gilpin not as documentation but as a necessary element in rendering the sea picturesque. Gilpin could identify the younger Van de Velde as a picturesque master in his ability to shape the results of his studies of sky, sea and shipping into pleasing compositions. In his essay 'On Picturesque Beauty', Gilpin cited Van de Velde as an example of the painter's

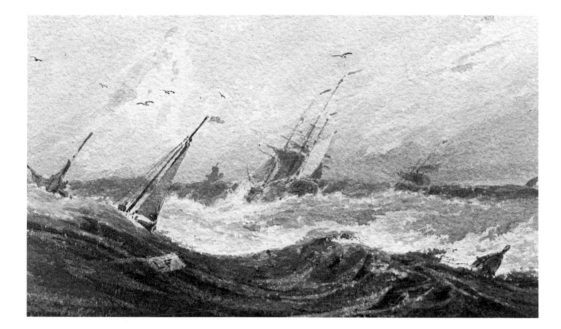

recognition of the picturesque wherever it may appear. 'What beautiful effects does Vandervelt produce from shipping? In the hands of such a master it furnishes almost as beautiful forms as any in the whole circle of picturesque objects.'[12]

Through the representation of the destruction of ships and the attendant loss of life due to either natural catastrophe or warfare, the marine sublime could be rendered picture-worthy. The combined appeal to empathy and picturesque formalism was powerful. According to Gilpin, 'As the distresses of mankind furnish the choicest subjects for dramatic scenes, so do they often for painting. And among these, no marine subject is equal to a shipwreck in the hands of a master.'[13] Marine disaster became a speciality of artists such as the Frenchman Claude-Joseph Vernet, the eighteenth century's most popular marine painter, with a broad popular audience in both France and England.

While Gilpin's picturesque was derived from art, particularly that of Claude, and rendered into neat aesthetic formulas, it did bring to bear on the natural landscape an aesthetic point of view. Thus picturesque formulas, while thrown off by artists and writers of the nineteenth century as strangling any fresh and natural response to landscape, did function as a spur to naturalism in the eighteenth century. It was for his success as a painter of skies that Gilpin cited Van de Velde in a note to his 'On Landscape Painting, a Poem': 'Nobody was better acquainted with the effects of sky, nor studied them with more attention, than the younger Vandervelt.'[14]

The conflict of naturalism and formula can be seen in the paintings of Vernet. His working directly from nature was legendary. Indeed, the account of his being lashed to the mast to observe at first hand the effects of a storm at sea became an archetype of the artist-hero confronting nature.[15] Yet his popular paintings of shipwrecks smacked of melodrama and artifice. In a letter of advice to Nicholas Pocock in 1780, Sir Joshua Reynolds expressed his ambivalence about Vernet's art. After recommending the younger Van de Velde as a model for the harmony of the elements in marine painting, Reynolds goes on to advocate the practice of painting in oils *en plein air*:

> I would recommend to you, above all things, to paint from nature instead of drawing; to carry your palette and pencils to the water side. This was the practice of Vernet, whom I knew in Rome; he then shewed me his studies in colours, which struck me very much, for that truth which those works only have which are produced while the impression is warm from nature; at that time he was a perfect

19 François Louis Thomas Francia *Boats on a Stormy Sea*, c.1808. Cat. 72.

In the first decade of the nineteenth century, Francia, a French emigré in London, developed a broad, forceful watercolour manner, much influenced by the drawings of Thomas Girtin, a fellow member of the Sketching Society. By 1808 Francia was producing dramatic seascapes and coastal views which effectively exploit the characteristics of this style and signal a lifelong predilection for marine subjects.

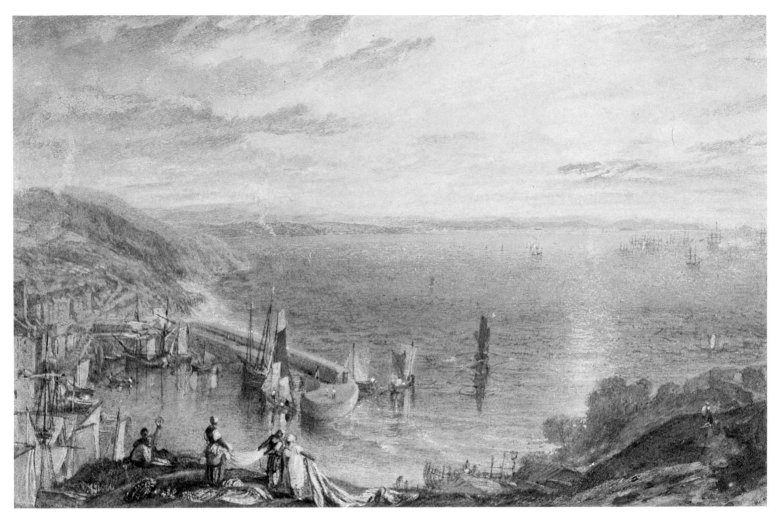

21 Joseph Mallord William Turner *Tor Bay from Brixham*, c.1816–17.
 Cat. 76.

Turner based this watercolour for Cooke's *Picturesque Views on the Southern
Coast of England* on drawings contained in two sketchbooks of 1811
(British Museum). It was engraved by Cooke in 1821. Taking a high
viewpoint above Brixham harbour looking east towards Torquay, Turner
conveys the effects of early morning light over the sea.

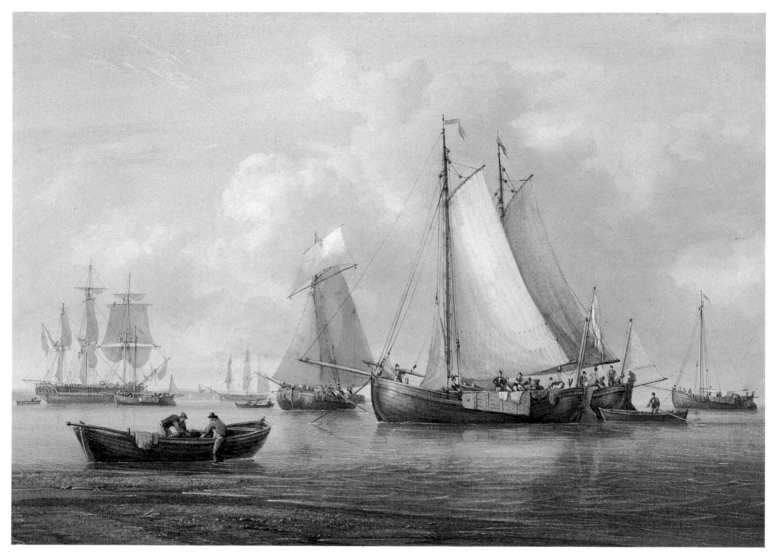

22 William Joy *Dutch Fishing Boats at Anchor in an Estuary*, ?1850s.
 Cat. 114.

Dutch fishing boats were common visitors to ports on the East Anglian
coast, where William and John Joy spent their early years. Such craft
were not the only Dutch influence on their art. Some of their water-
colours share with marine paintings by Norwich School artists an affinity
with the Dutch harbour scenes of the late seventeenth century.

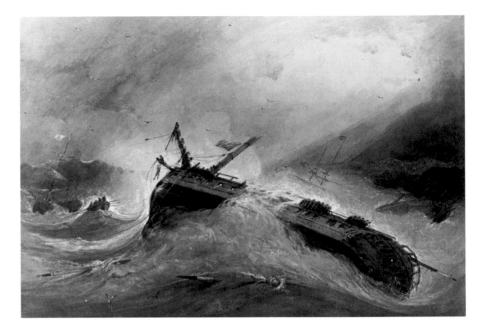

20 François Louis Thomas
Francia *A Stricken Vessel in a Gale*,
1830. Cat. 89.

In his earlier watercolours
Francia often depicted the
aftermath of storms with
abandoned or stranded vessels
lying on the coast, but here he
portrays the terror of shipwreck
itself and the plight of the sailors.
He was at this time involved in
charitable work for a lifesaving
society.

master of the character of water, if I may use the expression, he is now reduced to a
mere mannerist, and no longer to be recommended for imitation, except you would
imitate him by uniting landscape to ship-painting, which certainly makes a more
pleasing composition than either alone.[16]

Vernet's seascapes were, nonetheless, an important influence on marine artists such as Pocock
who sought to raise marine painting above its documentary status, or landscape painters such
as Philippe Jacques de Loutherbourg, on the lookout for sensational subject matter. After all,
Diderot had claimed that Vernet's marines were as much history paintings as the *Seven
Sacraments* of Poussin.[17]

Before he emigrated to England in 1771, de Loutherbourg had made a name for himself in
the Paris salons with dramatic shipwreck and coastal scenes in the style of Vernet. In England
he continued to paint the occasional shipwreck or sea battle in a theatrical and self-consciously
sublime manner, but his interests turned to other subject matter. That the seascapes he did
paint tended to be theatrical is not surprising in view of his long employment as a stage designer
for Drury Lane. His theatrical experience and an increasing preoccupation with the
representation of atmospheric effects came together in his Eidophusikon of 1781, essentially a
miniature theatre without actors, in which changing atmospheric effects were the stars of the
show. Several of the episodes presented at the Eidophusikon were of shipwrecks and storms
at sea.

If de Loutherbourg's concern with capturing the ever-changing effects of light and weather
connects with the overriding concerns of nineteenth-century marine painting, his interest in
the actual coastal scenery of England also foreshadows important aspects of the genre. He
made sketching excursions to Brighton, Worthing and the Kentish coast in 1784 and 1785.[18]
The results of his seaside touring and sketching appeared in the coastal views included in his
Picturesque Scenery of Great Britain (1801) and *The Picturesque and Romantic Scenery of England and
Wales* (1805), antecedents of such compilations of picturesque views as W. B. Cooke's
Picturesque Views on the Southern Coast of England (c.1811–26) and William Daniell's *A Voyage
Round Great Britain* (1814–25).

Artistic interest in coastal views reflected more than the aesthetic preoccupations of the
period. Social, mercantile and political developments drew the attention of the British public
to its coasts and the seas beyond.[19] Against the backdrop of the Napoleonic conflict, a reviewer
could claim special relevance for marine subjects:

In an island whose naval superiority is its pride, glory and best defence, a representation of such scenes as tend to the honour of those gallant spirits, whose prowess has obtained, and still preserves, that superiority, is a very proper subject for the pencil. Marine-painting, by this means becomes, in a degree, historical and biographical. . . .[20]

21 Richard Parkes Bonington
Sailing Vessels in an Estuary,
c.1826. Cat. 86.

The subtle tonalities and limited chromatic range of this watercolour suggest a date of execution just prior to the artist's trip to Italy in April 1826. The view may well be that of the Seine estuary between Quilleboeuf and Honfleur.

The association of marine painting with history painting echoes Diderot's claims for Vernet, and in a less warlike vein the biography of the nation could be read in Daniell's or Turner's cataloguing of its coasts and harbours.

Yet at the end of the eighteenth century, little existing marine painting seemed worthy of this exalted status. Dismissing the century-old Anglo-Dutch tradition, the *Naval Chronicle* on its first appearance in 1799 stated 'that Marine Painting is at present in its infancy in this country'. The problem was 'that this noble branch of the art is cramped, and greatly confined to portraits of particular ships, or correct representations of particular actions, which forbid the artist from indulging in the fine rolling phrenzy of imagination'.[21] In its early issues the periodical sought to guide and encourage the fledgling art.

As its title suggests, the *Naval Chronicle* was directed at a readership of seamen. In its twenty years of publication, it celebrated the exploits and achievements of the British navy, as well as providing a miscellany of nautical lore. Yet it took a broad view of its subject, and sought to forge links with the arts and literature. A regular feature was the list of 'marine designs, naval portraits, &c. in the exhibition of the Royal Academy' intended 'to render the works of Marine Artists known among professional men [i.e. mariners], and to record their annual exertions, who are some measure labouring in the same field with ourselves'.[22] Another running series, under the title of 'Marine Scenery', collected for the seaman's attention marine examples of the beautiful, picturesque and sublime.

The call for a new marine art was answered by J. M. W. Turner with a series of great seascapes in oils in the first decade of the nineteenth century, yet he produced no comparable body of marine watercolours in the period. Although he would do more than any other artist of his time to confound and explode the prejudices against watercolours, Turner seems in this instance to have had no interest in challenging the relegation of marine draughtsmanship to a documentary role. While he needed to assimilate the seascapes of Van de Velde, Vernet and de Loutherbourg as part of his programme of mastering the heritage of oil painting, there were no comparably imposing precedents in marine watercolours to be matched and surpassed.

23 William John Huggins *The Launch of the Honourable East India
 Company's Ship Edinburgh*, c.1825. Cat. 83.

The early part of Huggins's life was spent as a sailor on board East
Indiamen, and he was later employed to make portraits of the East India
Company's ships. Many of these, including the present example, were
engraved in aquatint by Edward Duncan. The *Edinburgh* was launched
from the yard of Wigrams & Green, Blackwall, on 9 November 1825. The
ship beyond the *Edinburgh* is the *Abercrombie Robinson*, which was to be
launched the following year.

24 William Callow *Plymouth Dockyard after the Fire*, c.1840. Cat. 103.

Callow received his first painting lessons from Charles Bentley (Cat. 108,
118). He later shared a studio in Paris with Thomas Shotter Boys, who
introduced him to Bonington's works and who persuaded him to become
a professional watercolourist. This example records the fire in the
Plymouth dockyard on the morning of 27 September 1840. HMS *Minden*
escaped the conflagration, but HMS *Imogene* and HMS *Talavera* were
both destroyed.

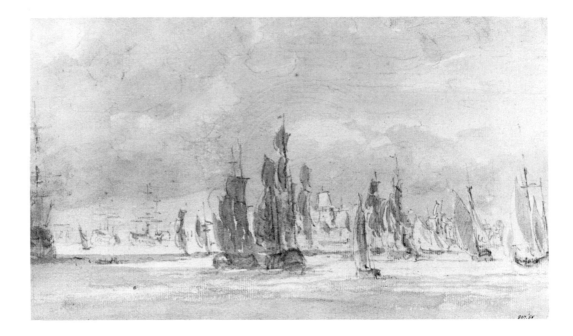

By 1800, however, watercolour had moved beyond the tinted drawing style prevalent earlier in the eighteenth century and had assumed functions beyond the purely documentary. The generation of John Robert Cozens, John 'Warwick' Smith and Thomas Hearne had introduced a more painterly approach to the medium of watercolours. Forms were no longer defined by pen outlines but modelled through an accumulation of touches of colour. By the mid-1790s collectors had become so enamoured of the new and more atmospheric effects that drawings which continued to feature pen work prominently were dismissed as mere sketches. Among the innovators, marine subjects were not common, but watercolours such as Hearne's *A Scene on Board HMS Deal Castle* (Plate 15) or Smith's *Bay Scene in Moonlight* (Plate 17) demonstrate the fresh approach that such non-specialists could bring to marine subjects.

The young J. M. W. Turner and Thomas Girtin seized on the advances made by artists such as Cozens and Hearne, expanding the technical range and expressive potential of watercolour, and, in so doing, gained a contemporary reputation as the virtual creators of the modern watercolour. Girtin's early death in 1802 and Turner's allegiance to the Royal Academy and growing practice as an oil painter kept these two acknowledged leaders of the watercolour revolution from participating in the crucial step in the advancement of watercolour as an autonomous art form—the organization of watercolour societies in the first decade of the nineteenth century.

In November 1804 a group of watercolourists, dissatisfied at their treatment by the Royal Academy, banded together to form the Society of Painters in Water-Colours. That they should have called themselves 'painters in watercolours' rather than draughtsmen is indicative of the change that had overtaken the medium. The following April the first of their annual exhibitions opened to the public and proved to be a great popular success.

One of the founding members of the Society was the sixty-four-year-old Nicholas Pocock. His contributions to the Society's first exhibition included both seascapes and landscapes. With his background as a sea captain and his awareness of picturesque principles, he must have seemed the embodiment of the new ideal of marine painter espoused by the *Naval Chronicle*, and, indeed, most of the periodical's illustrations in its early years were aquatints after Pocock's works. But Pocock's marines were, like his landscapes, old-fashioned, never advancing beyond the stylistic tenets of the 1780s, when he had begun his artistic career in earnest.[23]

If his position in the Society of Painters in Water-Colours was intended to foster within its ranks a thriving marine tradition, expectations were not fulfilled. When Pocock's watercolours were singled out for notice by *Ackermann's Repository of Arts* in its review of the Society's 1810

exhibition, it was within the context of a complaint about the absence of any other significant marine watercolours.[24]

When the Society's short-lived rival, the Associated Artists in Water-Colours, began exhibitions in 1807, it had its own marine representative in the person of Samuel Owen (who also provided illustrations for the *Naval Chronicle*). Samuel Prout and Louis Francia were also members, contributing marine subjects to the exhibitions; and John Christian Schetky, an exhibitor with the Associated Artists in the first three years of its existence, became a member in 1811. While Pocock had been more conservative than many of his younger colleagues in the Society, Owen was himself of the younger generation. Like Francia, Prout and even Schetky, he was influenced by the broad, deep-toned washes of Girtin. Apart from a few coastal scenes, Girtin himself showed no interest in marine subjects, yet elements of his influential style can be detected in many of the marine watercolours of the first half of the nineteenth century. The breadth and the tonal and atmospheric emphasis of the watercolour movement represented by Girtin were not, however, easily reconciled with the linear precision of traditional ship portraiture. In Owen's seascapes such as *Sailing Ships and Small Boats in a Rough Sea off the Coast* (Colour Plate 3), *Shipping on a Stormy Day* (Plate 18) or *Ships in a Stormy Sea*, these two stylistic modes coexist in an uneasy but not unattractive tension.

The underlying premise of the watercolour societies—that the medium was as capable of full-bodied, painterly effects as oil painting—promoted a type of watercolour art which fully displayed those capabilities. The public that patronized the watercolour exhibitions was considerably less concerned with accurate nautical detail than the traditional patrons of marine draughtsmanship had been.

Owen's career did not flourish. Perhaps he found balancing the demands of the exhibition watercolour and of the traditional sea piece too unrewarding. Although he lived until 1857, his professional life as an artist ended long before.

If marine painting of the Pocock variety never occupied more than a small part of the annual watercolour exhibitions and was seldom noticed by reviewers, marine subjects were by no means absent from the exhibitions or from the pages of the periodicals reviewing them. These marines tended to represent the coasts and offshore waters, and the artists who painted them stood outside the tradition of marine draughtsmanship represented by Pocock, Owen and Schetky. Comment on their works focused not on accuracy of nautical detail but on the effectiveness of the composition and the convincing representation of natural phenomena. Joshua Cristall and Samuel Prout, who joined the Society of Painters in Water-Colours after

23 John Constable *Fishing Boat with Net*, 1824. Cat. 80.

Beginning in 1824, Constable made a number of trips to Brighton with his family for the sake of his wife's health and that of his eldest son. Despite his distaste for the fashionable seaside resort, he was attracted by the forms of the fishing boats and colliers and made them the subject of a number of drawings and oil sketches.

25 John Wilson Carmichael *The Building of the Great Eastern*, 1857.
 Cat. 127.

His background as a shipbuilder's apprentice served the artist-
correspondent Carmichael well in this subject engraved for the *Illustrated
London News*. The *Great Eastern*, the third of Isambard Kingdom Brunel's
great shipbuilding masterpieces, was laid down at Millwall on the
Thames opposite Greenwich in 1854 and launched in 1858.

26 Thomas Sewell Robins *Mutton Cove, Plymouth*. Cat. 111.

Robins began exhibiting in 1829, the year of his admission to the Royal Academy Schools. In 1839 he was elected an associate member of the New Watercolour Society and exhibited prolifically before resigning in 1866.

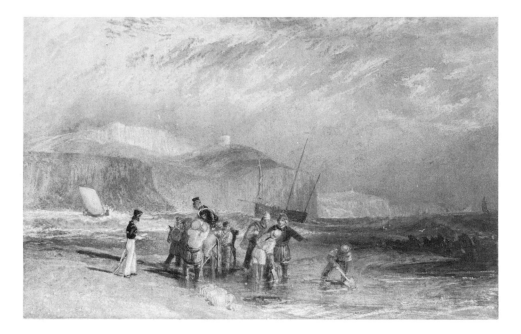

24 Joseph Mallord William Turner *Folkestone Harbour and Coast to Dover*, c.1829. Cat. 88.

Engraved by J. Horsburgh in 1831 for *Picturesque Views in England and Wales*, this watercolour belongs to the most ambitious series made by Turner for engraving. Against a dramatic background of rough sea and chalk cliffs, a group of men, supervised by coastguard officers, dig up kegs of contraband spirits. Smuggling was still a common activity on that particular part of the Kent coast in the early nineteenth century.

the Associated Artists' demise in 1812, were the most frequently cited and consistently praised in the first decades of the century. Copley Fielding, the president of the Society from 1831 to 1845, assumed the role of the Society's premier sea painter in the subsequent decades. Cristall's scenes of fishing activity are largely figural, and his fisherfolk have a monumentality which relates them to the gods and goddesses of his overtly classical subjects. In the years before Prout devoted himself to recording the medieval architecture of the Continent, he purveyed both the rustic and the coastal varieties of the picturesque in the watercolour exhibitions and in a series of compendiums of picturesque scenery.[25]

This coastal picturesque was a logical outgrowth of that particular development of picturesque theory that had moved away from Gilpin's broad aesthetic principles to a more narrowly defined set of characteristics and a more specific class of subject matter, generally rustic and tumbledown. The discovery of picturesque properties along the coasts had been pioneered by de Loutherbourg, Gainsborough and George Morland. A fishing boat was the equivalent of the humble cottage, while the dismasted Indiaman run aground, a speciality of Prout (Colour Plate 12), was the equivalent of the sublime castle ruin.[26]

It was the more sublime end of this spectrum of picturesque coastal imagery that increasingly engaged Louis Francia from about 1808. Early coast scenes and seascapes, such as his *Boats on a Stormy Sea* (Plate 19), display a broad patterning inherited from his colleague Girtin and not dissimilar to, though less striking than, that of John Sell Cotman at about the same time. Francia's later marines show more Turnerian drama, as in *A Stricken Vessel in a Gale* of 1830 (Plate 20). After his return to his native Calais in 1817, Francia served as a conduit by which knowledge of British watercolour techniques reached French artists. Through his pupils Eugène Isabey and Richard Parkes Bonington, he profoundly influenced the painting of seascapes on both sides of the channel.[27] Bonington's dashing and fluent marines (Colour Plate 27, Plate 21) were an influential alternative to the more highly worked-up approach of Turner.

The extent to which the picturesque response to the seaside had taken hold by the 1820s is clear in a letter from John Constable to his friend Fisher, written during his visit to Brighton in 1824. After bemoaning the fashionability of the resort—'the beach is only Piccadilly . . . by the sea-side'—he continued: 'There is nothing here for a painter but the breakers—& sky—which have been lovely indeed and always varying. The fishing boats are picturesque, but not so much as the Hastings boats, which are luggers.' In any event, such picturesque subjects had become 'hackneyed' and were in his opinion so 'little capable of that beautiful sentiment that landscape is capable of or which rather belongs to landscape, that they have done a great deal

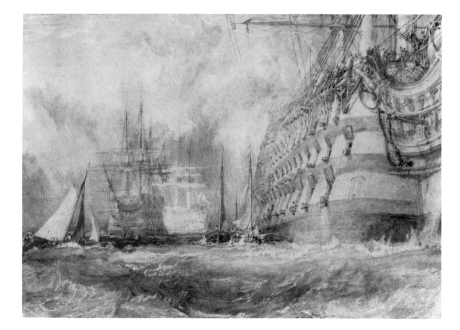

25 Joseph Mallord William Turner *A First-rate Taking in Stores*, 1818. Cat. 77.

Turner painted this watercolour during a visit to Farnley Hall, the home of his friend and patron Walter Fawkes, in November 1818. In response to Fawkes's request for 'a drawing of the ordinary dimensions that will give some idea of the size of a man of war', Turner produced this work in the course of a morning.

of harm to the art—they form a class of art much easier than landscape & have in consequence almost supplanted it . . .'.[28] It was not to seascapes and coastal views as such that Constable objected, but to the failure of artists to come to grips with the truths of landscape or seascape and instead to get by on picturesque formulas. His on-the-spot sketches produced during his trip from London to Deal in the East Indiaman *Coutts* in 1803 (Plate 22) and his visit to Brighton in 1824 (Plate 23) brought a directness of approach to marine subject matter, but remained an isolated and unpursued aspect of his art.

It was within the context of the picturesque coastal view that Turner approached marine painting in watercolour. Marine painting had demanded inclusion as one of the categories of his *Liber Studiorum*, and he had prepared monochrome wash drawings of several marine subjects for this demonstration of the scope of his art. But the first significant group of finished watercolours of marine subjects were those he provided for W. B. Cooke's *Picturesque Views on the Southern Coast of England*, begun about 1811. Turner's illustrations include both glowing panoramas looking out to sea such as *Tor Bay from Brixham* (Colour Plate 21) and dramatic storms and shipwrecks that recall Vernet. In so far as it represents actual points along the coast, the *Southern Coast* series continues the topographical nature of Turner's work in watercolours. Most of his subsequent marine watercolours were produced for other compilations of views. His work in the medium remained largely topographical, but this was topography far removed from Fuseli's characterization of it as the 'tame delineation of a given spot'.[29] In the watercolours of the 1820s for Cooke's *Rivers of England* and its sequel *The Ports of England*, Turner explored further the meeting of sea and land at its most sublime as well as in quieter moods.

Folkestone Harbour and Coast to Dover (Plate 24) from the series published as *Picturesque Views in England and Wales* displays Turner's virtuoso technique in the service of naturalism. With its vignette of contraband casks being dug up under the supervision of revenue officers, it also shows his concern to document not just the appearance of England's coastline but the nature of life lived along it.

The marine watercolours that he produced for his friend Walter Fawkes are among the few that are not also topographical in nature. *A First-rate Taking in Stores* (Plate 25) is a splendid example, which, like its companions, seems to have resulted from a desire to convey in watercolours a sense of the immensity of the sea and the great ships. The large *Whiting Fishing off Margate* (Colour Plate 1) is specifically placed, as were his other coastal scenes, but it seems to have been conceived, or was at least exhibited, as part of a Vernet-like pairing, its luminous calm being contrasted with the dark turbulence of *The Storm* (British Museum).

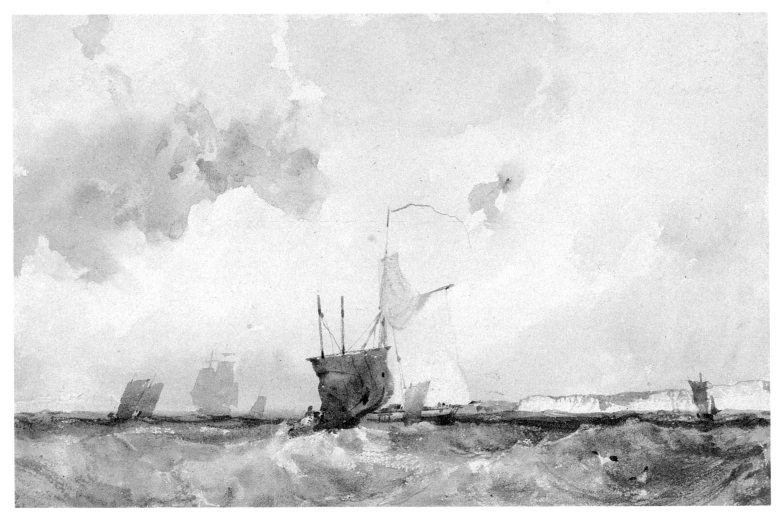

27 Richard Parkes Bonington *Vessels in a Choppy Sea*, c.1824–5. Cat. 82.

Bonington probably sketched this watercolour from nature during his year of residency at Dunkirk. It is the basis for an oil painting (Wallace Collection), which may have been exhibited at the Paris Salon of 1824, and a more highly finished watercolour dated 1825 (Budapest).

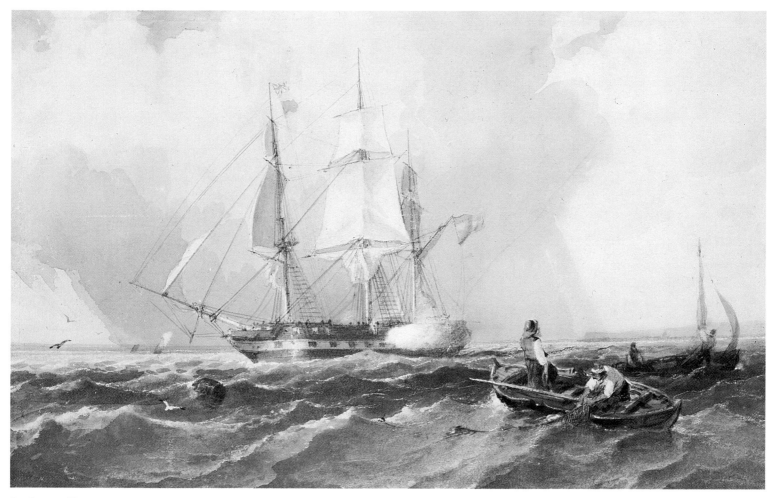

28 George Chambers *A Frigate Firing a Gun*, c.1835. Cat. 95.

Like so many marine watercolourists of his generation, George Chambers formed his style in emulation of Bonington's brilliant palette and virtuoso handling. He was, in addition, extremely attentive to details such as rigging and fishermen's costumes.

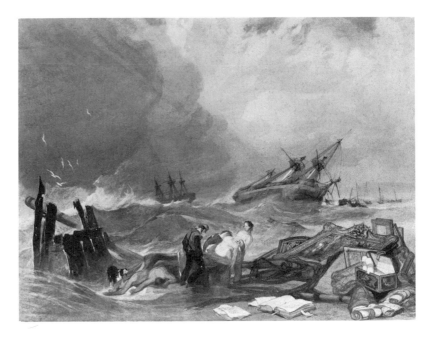

Turner retained the eighteenth-century structures of topography, the sublime and the picturesque for his watercolours, but radically transformed these elements.[30] The most sublime of marine subjects for Gilpin, Vernet and de Loutherbourg—the shipwreck—remained a powerful icon for Turner, as it did for Francia, John Sell Cotman and Clarkson Stanfield. Indeed, the shipwreck has been recognized as one of the quintessential Romantic themes.[31] Generally it was the naturalism and the sense of personal identification evident in nineteenth-century treatments of the subject that separated them from their predecessors. Francia's membership of a lifesaving society shows that his interest in the catastrophes he depicted (Plate 20) went beyond the aesthetic, and suggests that whatever symbolic weight such imagery might carry, it was also firmly rooted in actual events and concerns.

Cotman's East Anglian background may have predisposed him to marine subjects. Although his marine watercolours are few in number, they are among the most striking of the early nineteenth century. *The Dismasted Brig* (British Museum) is a distillation of Romantic shipwreck imagery into a starkly formal arrangement of fragmented blocks of colour.[32] *The Lee Shore, with the Wreck of the Houghton Pictures* (Plate 26), a collaboration with his son, Miles Edmund Cotman, represents the more grandiose aspect of the exhibition watercolour, and adds the narrative frisson of having art as well as human life in peril.

The Copley Fielding seascapes in the Society of Painters in Water-Colours exhibitions, Turner's watercolours exhibited in Cooke's Gallery and disseminated through engravings, Bonington's marines and those of the various Boningtonistes all testify to the activity in marine watercolours during the 1820s, 1830s and 1840s. Yet the vitality of the tradition depended on one's critical viewpoint. Ackermann's reviewer in 1810 noted that 'in a country so mighty and unrivalled in naval power, it is singular that there should be so few marine painters'.[33] John Eagles, reviewing the 1842 Royal Academy exhibition, echoed this:

> It is somewhat singular that this country should have so few marine painters. How seldom do we see one picture that would remind us that Vandervelt visited our coasts. The insignificant pieces of this kind that are occasionally exhibited, generally represent small vessels, a sea of no great character, and gaudy skies. How unlike Vandervelt and Backhuyen [*sic*]! It is said that the French artists excel us in this line of art—a line which might be considered particularly adapted to the feelings of Englishmen. Stansfield [*sic*], indeed, paints coasts, and the waters that wash them, with considerable effect; but his pictures are scarcely sea-pieces.[34]

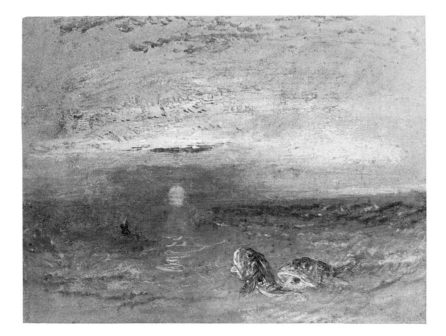

27 Joseph Mallord William Turner *Sunset at Sea, with Gurnets*, c.1840. Cat. 102.

This is one of a number of works in the 1840s in which Turner expressed a fascination with grotesque fish and sea monsters. The watercolour probably belonged to John Ruskin. Although more elaborate, it is related to a group of drawings of marine subjects bought by Ruskin from Turner's housekeeper, Mrs. Booth, after the artist's death.

Stanfield had yet to produce those dramatic late oils such as *On the Dogger Bank*, *The Abandoned* or *The Day after the Wreck* which would secure his position as the Victorian master of marine art.[35] As for Turner's later marines, Eagles dismissed them as absurdities and hallucinations.

It was Eagles's contemptuous criticism of Turner that prompted the painter's young admirer, John Ruskin, to come to his defence and led to the publication of the first volume of *Modern Painters*. The first of Ruskin's two extended treatments of marine painting appeared as part of his methodical dissection of the elements of landscape in *Modern Painters*. Under the heading 'Of Truth of Water', he considered the painting of the sea itself. The second came twelve years later, in the text he provided for a reissue of Turner's *Ports of England* under the new title *The Harbours of England*. This time his subject was the painting of ships. In both cases, Ruskin's intention was to show the superiority of Turner to both the old masters and his contemporaries, but these passages, as well as others less directly concerned with the specific problems of painting the sea, helped to form a new aesthetic of marine painting in both oils and watercolours in the second half of the nineteenth century.

For Ruskin, Van de Velde and Bakhuizen did not represent a golden age of marine painting that needed to be recaptured; on the contrary, they epitomized an unintelligent conventionalism that had long laid a dead hand across the genre. Copley Fielding, master of 'the desolate sea', Stanfield, master of 'the blue, open, boundless ocean',[36] and above all Turner had brought new life to the seascape. That their achievement was in any way rooted in the Van de Velde tradition was not acknowledged by Ruskin. While he could not deny the importance of Van de Velde in Turner's early work, he viewed it in purely negative terms: 'I know that Turner once liked Vandevelde, and I can trace the evil influence of Vandevelde on most of his early sea-painting.'[37] Indeed, the great early sea pieces, which for most nineteenth-century art lovers were Turner's most accessible and therefore most valued achievements, were not highly regarded by Ruskin. His claim for the superiority of Turner as a painter of the sea rested on later works such as the oil *Slavers Throwing Overboard the Dead and Dying—Typhoon Coming on* of 1840 and presumably on the comparable watercolours of the 1840s such as the *Dawn after the Wreck* (Courtauld Institute) or *Sunset at Sea, with Gurnets* (Plate 27).

Ruskin made the crucial point that all marine painting depends upon conventions. Indeed, the point could be extended to all art, but for Ruskin, dedicated to the intensive observation of nature, the unceasing movement of the sea frustrated any prolonged, painstaking documentation of its appearance. The need for conventions of representation was inescapable:

29 William Joy *HMS Vanguard, St. Vincent and a Royal Yacht at Spithead,*
1850s. Cat. 113.

William Joy's own watercolours are perhaps more restrained than his
collaborations with his brother John. The drawing of shipping is
extremely detailed and an unusual palette is employed to render
atmospheric effects. Between HMS *Vanguard* on the left and HMS *St.
Vincent* on the right is a royal yacht, either the *Elfin* or the *Victoria and
Albert I*, flying the Royal Standard to indicate the presence of the
sovereign.

30 Humphrey John Julian *The Admiral's House, Simon's Town, Cape of Good Hope*, 1844. Cat. 107.

In August 1843 Julian was appointed first lieutenant on board HMS *Cornwallis*, the flagship of the East Indies station under Sir William Parker. It was necessary to call at the base at Simonstown for the purpose of taking on provisions and water on both the outward and the homeward journey to the East.

28 (*left*) James Abbott McNeill Whistler *Beach Scene*, 1883–4. Cat. 140.

In the early 1880s Whistler turned his attention to the medium of watercolours. His first exhibition of watercolours, which he called '*Notes*'—'*Harmonies*'—'*Nocturnes*', was held in 1884. While this beach scene of about that time brings to mind similar subjects by the French artist Boudin and the English watercolourist David Cox, Whistler strikes his own note of elegant abstraction.

29 (*right*) James Abbott McNeill Whistler *The Return of the Fishing Boats*, c.1890. Cat. 141.

Whistler's assertion in the 'Ten O'Clock' Lecture that 'seldom does Nature succeed in producing a picture' did not preclude his own sketching from nature. Through the 1880s and 1890s he was a frequent visitor to the seaside, where he created some of his most atmospheric water-colours. Both in terms of technique and composition, watercolours such as this one provided influential models for artists as varied as Steer and Wyllie.

The sea never has been, and I fancy never will be nor can be painted; it is only suggested by means of more or less spiritual and intelligent conventionalism: and though Turner has done enough to suggest the sea mightily and gloriously, after all it is by conventionalism still . . .[38]

For Ruskin the conventions employed by a sea painter could not be stale inheritances but had to be freshly minted and grounded in the thoughtful and loving perception of nature. For the marine painters, such as Henry Moore, who read Ruskin and were affected by their reading, the conventions tended to be of the highly wrought variety.

In his essay for *The Harbours of England*, Ruskin combined a paean to ships and boats—'there is not, except the very loveliest creatures of the living world, anything in nature so absolutely notable, bewitching, and according to its means and measure, heart-occupying, as a well-handled ship under sail in a stormy day'[39]—with the relegation of the painting of ships and shipping to the rank of second-rate art. His critical justification was that no great art ever had as its subject the works of man. The marine paintings of Stanfield and Turner escaped his strictures by representing the works of man overwhelmed by the forces of nature. Yet the argument tended to shift back and forth between the inappropriateness of shipping as a subject of high art and the inability of painters to do the subject justice. Ruskin's preoccupation with precise and detailed observation led him into a lengthy demonstration of the inadequacy of artists' representations of complex rigging, which echoed all too closely the sentiments of the old tar he ridiculed for preferring the ship portraitist William Huggins to Turner.

Ruskin's focus on the sea itself, along with his strictures on the representation of shipping and his advocacy of a freedom from the time-honoured but inadequate conventions of marine painting, encouraged artists to re-examine the proposition of a marine art without ships. Byron had asked in 1821: 'Did any painter ever paint the sea *only* without the addition of a ship, boatwreck, or some such adjunct? Is the sea itself a more attractive, a more moral, a more poetical object, with or without a vessel breaking its vast but fatiguing monotony?'[40] While Turner and David Cox had explored the possibilities of compositions of sea and sky alone in watercolour studies, and Constable in drawings and oil sketches had produced marines in which the presence of shipping and shoreline were no more than vestigial, for the first half of the nineteenth century Byron's first question could be answered largely in the negative. The young landscape painter Henry Moore, before he had yet produced any of the marines that were to make him one of the most popular seascapists of his own time, commented: 'There is one thing

respecting the sea I never saw truly given in a painting—viz, its size and extent as seen from high cliffs—it is truly wonderful.'[41] Moore would go on to produce in watercolours and oils works which captured the vastness of the sea itself. But if Ruskin provided an intellectual stimulus and a liberating influence on artists such as Moore and John Brett, it is perhaps equally true that these artists turned to panoramic depictions of the open sea as a means of evading the microscopic detail of Ruskinian landscape without actually breaking from Ruskinian precepts. For as Ruskin himself realized, the constant flux of the sea demanded some more fluid approach.

Alfred William Hunt was so imbued with Ruskinian principles of minute fidelity to nature that even Ruskin found his detail excessive. Hunt himself recognized the deadening effect this could have on his works. He at times worked backwards from a highly finished watercolour, sponging and rubbing away at the surface to achieve the sort of atmospheric quality which is so evident in '*Blue Lights*', *Tynemouth Pier—Lighting the Lamps at Sundown* (Colour Plate 31). In 1880 Hunt in a thoughtful essay on the state of English landscape painting characterized what the limitations of the Ruskinian approach had wrought. The sweeping away of old formulas had left a vacuum that had been filled by a preoccupation with the accurate rendering of natural fact, and this was not enough. Hunt turned to marine painting to illustrate his point:

We have our wave drawn, modelled, and tinted for us with an accuracy which leaves us little to desire, and gives us much to delight in. We can recognize the moment when its crest has just fallen—fallen away in froth and foam, which are faintly veining and fast melting into the green depth—not so fast but that a network of pale grey is being dragged forward in the rise of the next mounting wave. The perspective and foreshortening of all this tracery of bubbles on the sides of each dark mounded mass are given, one might almost say, with as much correctness as those of any other 'pattern' on sea and land. There is the low grey sky too, and the thin-sailed ship, labouring and straining along its path over hills and dales of bitter sea. Or else Old Ocean is painted for us on one of those days when 'sleek Panope and all her sisters' might sport on his surface. If they are not there, or if we do not somehow imagine, on looking at the picture, that they ever could be there, it is certainly from no want of skilful rendering of water surface, or unflinching setting down of its most vivid colours as the artist has seen them. . . . But even while we are most dazzled by the brilliancy of such a triumph of descriptive art, by the strangeness of such an

30 Philip Wilson Steer *A Grey Day*, 1919. Cat. 153.

From the 1910s until his death, the seaside provided a frequent subject for Steer's work in watercolours. His fluid and economical style drew its inspiration from the wash drawings of Turner, Brabazon and Whistler.

31 Alfred William Hunt '*Blue Lights*', *Tynemouth Pier—Lighting the Lamps at Sundown*, 1868. Cat. 135.

In a letter of 1869, Hunt commented that the foreground of this watercolour 'does want a little explanation to all who are not engineers or "Tyne commissioners".' He went on to describe in detail the depicted tramway for laying in a breakwater. If the foreground structure was not recognizable to the critics, that did not hamper their enthusiasm. When the subject was exhibited at the Society of Painters in Water-colours in 1866 (probably this watercolour, although it bears a later date), the critic of the *Athenaeum* described it as 'a magnificent study of sea and cliffs at sundown' in which 'the artist exhibits a startling sense of the tremendous in-roll of the water, its weight and terrible force, that is wonderfully expressed by modest means.'

32 John Everett *Deck Scene, Kylemore, Barque*, c.1930. Cat. 154.

Everett trained at the Slade (1896–8) where his friends were Augustus John and William Orpen, both of whom lodged with him at 21 Fitzroy Street, London. In May 1898 he signed on the *Iquique* as an ordinary seaman. Thirty years later he was on board the barque *Kylemore* (November 1928 – January 1929 Calais to Pointe à Pitre, Guadeloupe; November–December 1930, Le Havre to Black River, Jamaica). This typical shipboard view was later made into an aquatint.

31 Hercules Brabazon Brabazon
Mouth of the Humber: after Turner.
Cat. 138.

Brabazon, a brilliant amateur,
made many studies based on the
work of other artists, but he was
particularly attracted by the
watercolours of Turner. This
drawing, one of over four hundred
'translations' that he made of
Turner's works, freely interprets a
watercolour that Turner
produced in the mid-1820s for the
Rivers of England.

apparently complete inventory of one of nature's treasure-chambers of fine things, there springs up within us a strange sensation of something wanting still: . . . we admire the artist's extraordinary skill, we are thoroughly grateful to him for reminding us of what he has copied so well; but the admiration and the gratitude and the intellectual joy of examining bit by bit such a picture, make up altogether a pleasure different in kind from that which we derive from a great imaginative work of art.[42]

Even before Hunt penned his critique, artists were reacting to the situation Hunt described. In the influential works of James McNeill Whistler, the domination of descriptive detail gives way to the shaping intelligence of the artist. In such watercolours as *Beach Scene* (Plate 28) or *The Return of the Fishing Boats* (Plate 29), sea, sand and sky are no longer objects of analytical inquiry but shapes and hues to be manipulated by the artist into aesthetic arrangements. Whistler's marine watercolours, like those of Philip Wilson Steer (Plate 30) later, are less about nature than about art.

In this art-dominated conception, past models of style could be resurrected for current use. The amateur watercolourist Hercules Brabazon Brabazon turned back to the broad wash techniques of Peter DeWint, David Cox and J. M. W. Turner. Even so he took as models for his own fluent watercolour style the free wash studies rather than the finished watercolours of these earlier masters. His copy (Plate 31) of one of Turner's illustrations for the *Rivers of England* characteristically reinterprets the model with a freedom and looseness of handling that derive in large part from Turner, but have little to do with the particular Turner at hand. It was the style of these earlier watercolourists, not the naturalistic impulse which lay behind that style, which appealed to artists such as Brabazon.

The ship portraitists and marine specialists carried on, taking from mainstream developments what they could turn to account in their work, but once the naturalism that had, in one guise or another, informed all the developments of marine painting since the eighteenth century, ceased to function as the ground of advanced painters, a gap such as had never before existed opened between the marine artist and those at the forefront of landscape art. The gap would not be closed.

Notes

The Art of Marine Drawing
Roger Quarm

1. D. Serres and J. T. Serres, *Liber Nauticus and Instructor in the Art of Marine Drawing* (London, 1805–6), Address, Part I.
2. Ibid, Address, Part II.
3. Joseph Farington, *Diary*, 22 February 1795.
4. See H. Ogden and M. Ogden, *English Taste in Landscape in the Seventeenth Century* (Michigan, 1955), p. 42. The conclusion is that 'harbour landscapes' (a term used to describe most sea pieces) were not common in English collections in the first half of the seventeenth century. Interest in marine paintings seems to have grown very slowly in the second half of the century.
5. Tapestries to the designs of H. C. Vroom hung in the House of Lords until their destruction in the 1834 fire. They were engraved by John Pine in 1739.
6. Navy Records Society, *The Tangier Papers of Samuel Pepys* (London, 1935), p. 156.
7. National Maritime Museum, Department of Pictures, note in files by M. S. Robinson.
8. E. Croft Murray and P. Hulton, *Catalogue of British Drawings*, vol. I (London, 1960).
9. Navy Records Society, *A Descriptive Catalogue of the Naval MSS in the Pepysian Library* (London, 1928), pp. 470–1.
10. Navy Records Society, *The Tangier Papers of Samuel Pepys* (London, 1935), p. 241.
11. National Maritime Museum (74-15).
12. Walpole Society, vol. XVIII (1929–30), *Vertue Notebooks* (I), p. 74.
13. H. Walpole, *A Catalogue of Engravers who have been born, or resided in England* (London, 1786; 2nd edn, p. 96).
14. M. S. Robinson, *Van de Velde Drawings: A Catalogue of Drawings in the National Maritime Museum made by the Elder and the Younger van de Velde*, vol. I (Cambridge, 1958), p. 12.
15. Walpole Society, vol. XXII (1933–4), *Vertue Notebooks* (III), p. 113.
16. R. A. Kingzett, 'A Catalogue of the Works of Samuel Scott', Walpole Society, vol. XLVIII (1980–2), Appendix A.
17. P. D. Fraser, 'Charles Gore and the Willem van de Veldes', *Master Drawings*, vol. 15, no. 4, p. 375.
18. G. F. Bell and T. Girtin, 'The Drawings and Sketches of John Robert Cozens', Walpole Society, vol. XXIII (1934–5), pp. 8, 9.
19. British Art Center, Yale University.
20. G. Callender, *Masters of Maritime Art: a loan exhibition of drawings from the collection of Captain Bruce S. Ingram, OBE, MC* (London, 1936), p. 11.
21. M. Rouquet, *The Present State of the Arts in England* (London, 1755), p. 60.
22. Richard Paton (1717–91), one of the principal painters of naval actions of the second half of the eighteenth century. His work, 'uneven in quality and style', was commented on in relation to Serres by Sandby in 1784: 'Alas poor Paton, hide diminished head, your topsails are lowered' (letter from Paul Sandby to James Gandon, the architect).
23. According to Archibald, however, Serres may have been in England by 1750 (E. Archibald, *A Dictionary of Sea Painters* (Woodbridge, 1980).
24. *London Current*, 6 May 1780.
25. *Candid Review*, 1778.
26. *Strictures*, 1778.
27. For a full account of the British monarchy and their yachts, see C. M. Gavin, *Royal Yachts* (London, 1932).
28. Letter from Paul Sandby to James Gandon, 3 February 1783: 'My friend Serres is fitting out a great fleet, and has taken many prizes from Luttrell, Rodney and Co, and is at present at the head of naval affairs' (W. Sandby *Thomas and Paul Sandby Royal Academicians, some account of their lives and works* (London, 1892).
29. W. T. Whitley, *Artists and Their Friends in England, 1700–1799* (London and Boston, 1928). The source of this anecdote is unfortunately not given.
30. The Royal Kalendars clearly demonstrate that at any one time there could be a number of people holding a title such as Marine Painter in Ordinary to a Member of the Royal Family. An artist might often petition for the title after the royal personage concerned had bought some of their works. But even when it had been granted the title did not mean that any retainer was paid – nor was there any obligation to purchase further works. Naturally, however, commissions would invariably be placed with one or other of the people holding the official title. *in litt.* The Hon. Mrs Jane Roberts—R. Quarm 16 September 1986.
31. M. Hardie, *Watercolour Painting in England*, vol. I, *The Eighteenth Century* (London, 1966), p. 231.
32. PRO Adm 3/79, f.164.
33. Holograph to Richard Bright Esq., Bristol, 6 February 1804, NMM AGC/22/4.
34. National Maritime Museum, drawing M1042, *Hotham's Action against the French off L'Orient, May 22, 1812*.
35. Thomas Luny, inventories covering the years 1807–37. Private collection.
36. M. Rouquet, *The Present State of the Arts in England* (London, 1755), pp. 60–1.
37. National Maritime Museum, presented to Greenwich Hospital by George IV in 1829.
38. S. F. L. Schetky, *Ninety Years of Work and Play. Sketches from the Public and Private Career of John Christian Schetky* (London, 1877), pp. 129–30.

'Dear Sir,—I thank you for your kind offer of the Temeraire; but I can bring in very little, if any, of her hull, because of the Redoutable. If you will make a sketch of the Victory (she is in Hayle Lake or Portsmouth harbour) three-quarter bow on starboard side, or opposite the bow port, you will much oblige; and if you have a sketch of the Neptune, Captain Freemantle's ship, or know any particulars of Santissima Trinidada, or Redoutable, any communication I will thank you much for Your most truly obliged

J. M. W. Turner

'P.S.—The Victory, I understand, has undergone considerable alterations since the action, so that a slight sketch will do, having my own when she entered the Medway (with the body of Lord Nelson), and the Admiralty or Navy Office drawing.'

September 21, 1824.

'Dear Sir,—Your sketches will be with you, I trust, by (the Rocket coach) to-morrow evening. They shall be sent to the coach-office this evening. *Many* thanks for the loan of them, and believe me to be your most truly obliged.

J. M. W. Turner

To J. C. Schetky, Esq.'

39. See M. Butlin and E. Joll, *The Paintings of J. M. W. Turner* (New Haven and London, 1977). Letter from Henry Tijou to Sir John Leicester of 22 December 1824 (published by Douglas Hall).
40. A precedent for this may be seen in Samuel Scott's development into oil paintings of Peircy Brett's accomplished drawings of naval actions of the 1740s. See R. A. Kingzett, 'Catalogue of the Works of

Samuel Scott', Walpole Society, vol. XLVIII, p. 31.

41. S. F. L. Schetky, *op. cit.*, p. 162.

42. Ibid., p. 220.

43. Of whose work Chambers was certainly aware, possibly as early as 1830, see J. Watkins, *Life and Career of George Chambers* (London, 1841), p. 36: 'Lord Mark Kerr gave him a letter of introduction to Mr. Carpenter, the picture-dealer of Bond Street, desiring him to introduce Chambers to all his friends. Carpenter possessed several pictures by Bonnington, which he shewed to Chambers, telling him that when he could paint one as good, he would hang it up beside them.'

44. Ibid., pp. 39–40.

45. Ibid., p. 44.

46. Ibid., pp. 112, 113.

47. Ibid., pp. 49, 50 (source given as 'the daily papers').

48. National Maritime Museum.

The Wider Sea: Marine Watercolours and Landscape Art
Scott Wilcox

1. John Constable, *Various Subjects of Landscape, Characteristic of English Scenery*, 2nd edn (London, 1833).

2. Joshua Reynolds, *Discourses on Art*, ed. Robert Wark (New Haven and London, 1975), p. 52. Throughout the critical literature of the eighteenth and nineteenth centuries, there are frequent references to Van de Velde, variously spelled and undifferentiated as to the father or the son. At times it perhaps stood for a composite of the two, although more often it seems to have indicated the son.

3. The extensive collection of Van de Velde drawings in the National Maritime Museum includes over fifty sheets from Sandby's collection, as well as drawings once owned by Jonathan Richardson the Elder, Benjamin West, Thomas Lawrence and J. M. W. Turner.

4. Walter Thornbury, *The Life of J. M. W. Turner, R.A.*, rev. edn (London, 1904), p. 8. This anecdote is taken as the starting point for a consideration of Dutch influences on Turner by

A. G. H. Bachrach, 'J. M. W. Turner's "This Made Me a Painter": A Note on Visual Perception and Representational Accuracy', in *Light and Sight: An Anglo-Netherlandish Symposium* (Amsterdam and London, 1974), pp. 41–61.

5. One of the most significant of the early marine oils by Turner was *The Bridgewater Seapiece*, painted for the Duke of Bridgewater as a pendant for a Van de Velde seascape. For the details of the commission and its subsequent critical history, see Martin Butlin and Evelyn Joll, *The Paintings of J. M. W. Turner*, rev. edn, 2 vols (New Haven and London, 1984), vol. 1, pp. 12–13. Luke Herrmann, 'Turner and the Sea', *Turner Studies*, No. 1, 1981, pp. 4–18, reviews the artist's work as a painter of seascapes in oil.

6. Reproductions after both Van de Velde and Bakhuizen were included in *The Beauties of the Dutch School; Selected from Interesting Pictures of Admired Landscape Painters* (London, 1793).

7. Andrew Wilton, *Turner and the Sublime*, exh. cat. (London, 1980), pp. 17–24.

8. William Falconer, *The Shipwreck: A Poem*, 1811 edn (London, 1811), p. ii.

9. James Stanier Clarke, *Naufragia, or Historical Memoirs of Shipwrecks, and of the Providential Deliverance of Vessels* (London, 1805), preface.

10. Hugh Blair, *Lectures on Rhetoric and Belles Lettres*, 3rd edn (London, 1787), p. 58; Dugald Stewart, *Philosophical Essays*, 3rd edn (Edinburgh, 1818), p. 422. Both are cited by Wilton in *Turner and the Sublime*, p. 46.

11. William Gilpin, 'On Picturesque Travel', in *Three Essays on Picturesque Beauty; on Picturesque Travel; and on Sketching Landscape* (London, 1792), p. 43.

12. Gilpin, 'On Picturesque Beauty', *Three Essays*, p. 27.

13. William Gilpin, *Observations on the Western Parts of England* (London, 1798), p. 341.

14. Gilpin, 'On Landscape Painting, a Poem', in *Three Essays*, p. 34.

15. George Levitine, 'Vernet Tied to a Mast in a Storm: The Evolution of an Episode of Art Historical Romantic Folklore', *Art Bulletin*, vol. 49 (June 1967),

pp. 93–100.

16. The letter is transcribed in full as an appendix to David Cordingly, *Marine Painting in England, 1700–1900* (London, 1974), pp. 181–2.

17. [Philip Conisbee], *Claude-Joseph Vernet, 1714–1789*, exh. cat. (London, 1976).

18. Loutherbourg's shipwrecks, topographical subjects and the Eidophusikon are surveyed in [Rudiger Joppien], *Philippe Jacques de Loutherbourg, R.A., 1740–1812*, exh. cat. (London, 1973).

19. Some of these developments are outlined in the chapter 'Coastal Scenes' in Louis Hawes, *Presences of Nature: British Landscape, 1780–1830*, exh. cat. (New Haven, 1982), which also provides a good bibliography.

20. Review of a print of the battle of Copenhagen by Stadler after Nicholas Pocock, *The Monthly Magazine, or, British Register*, vol. 12 (1 September 1801), p. 140.

21. *Naval Chronicle*, vol. 1 (1799), pp. 517–18. John Gage discusses the periodical in connection with Picturesque theory in 'Turner and the Picturesque—I', *Burlington Magazine*, vol. 107 (January 1965), p. 23.

22. *Naval Chronicle*, vol. 1, p. 517.

23. The most complete account of Pocock's life and art is David Cordingly, *Nicolas Pocock, 1740–1821* (London, 1986).

24. *Ackermann's Repository of Arts*, vol. 3 (1810), p. 432.

25. For Cristall, see Basil Taylor, *Joshua Cristall (1768–1847)*, exh. cat. (London, 1975); for Prout, Richard Lockett, *Samuel Prout, 1783–1852* (London, 1985).

26. John Ruskin in *The Harbours of England* wrote of the 'architecture of the sea', equating the fishing boat with the cottage, 'only far more sublime than a cottage ever can be'. *The Works of John Ruskin*, ed. E. T. Cook and Alexander Wedderburn, 36 vols (London, 1903–9), vol. 13, p. 24.

27 For Francia, see Colin Shaw Smith and Anthony Reed, *Louis Francia and His Son Alexandre*, exh. cat. (London, 1985), and Marcia Pointon, *Bonington, Francia & Wyld* (London, 1985).

28. *John Constable's Correspondence*, ed. R. B. Beckett, 6 vols

(Ipswich, 1962–8), vol. 6, p. 171.

29. Lecture IV, from Henry Fuseli, *Lectures on Painting* (London, 1820), p. 27.

30. This topic is admirably treated by Wilton in *Turner and the Sublime*.

31. T. S. R. Boase, 'Shipwrecks in English Romantic Painting', *Journal of the Warburg and Courtauld Institutes*, vol. 22 (1959), pp. 332–46, and Lorenz Eitner, 'The Open Window and the Storm-tossed Boat: An Essay in the Iconography of Romanticism', *Art Bulletin*, vol. 37 (Dec. 1955), pp. 281–90, are important articles. See also Adele M. Holcomb, 'John Sell Cotman's *Dismasted Brig* and the Motif of the Drifting Boat', *Studies in Romanticism*, vol. 14 (Winter 1975), pp. 29–40, and Martin Meisel, 'Seeing It Feelingly: Victorian Symbolism and Narrative Art' (on Stanfield's *The Abandoned*), *The Huntington Library Quarterly*, vol. 49 (Winter 1986), pp. 67–92.

32. Holcomb, op. cit., considers this watercolour in detail, drawing a distinction between depictions of the moment of shipwreck and representations of helplessly drifting vessels.

33. *Ackermann's Repository of Arts*, vol. 3, p. 432.

34. *Blackwood's Edinburgh Magazine*, vol. 52 (July 1842), p. 34.

35. See [Pieter Van der Merwe], *The Spectacular Career of Clarkson Stanfield, 1793–1867*, exh. cat. (Newcastle, 1979).

36. Ruskin, *Works*, vol. 3, p. 536.

37. Ibid., p. 498.

38. Ibid., p. 499.

39. Ruskin, *Works*, vol. 13, p. 24.

40. George Gordon, Lord Byron, *Letter to **** ****** [John Murray], Esqre, on the Rev. W. L. Bowles's Strictures on the Life and Writings of Pope*, reprinted in *The Works of Lord Byron: Letters and Journals*, ed. Rowland Prothero, 6 vols (London, 1898–1901), vol. 5, p. 544.

41. Quoted in Frank Maclean, *Henry Moore, R.A.* (London, 1905), p. 33.

42. Alfred William Hunt, 'Modern English Landscape Painting', *The Nineteenth Century*, vol. 7 (May 1880), pp. 784–5.

32

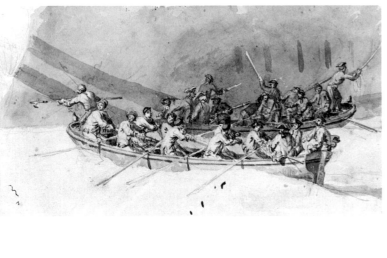

33

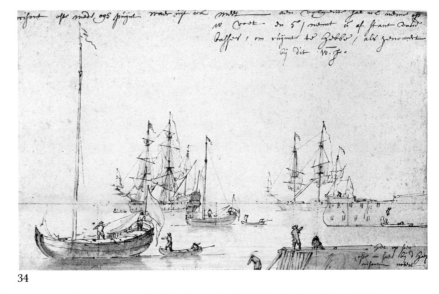

34

Origins

The impact of the Van de Veldes upon marine painting in England was to be long lasting.

32 Francis Place *Men-of-war in a Storm*, c.1717. Cat. 12.
This late drawing by Place, somewhat Van de Velde-like in its accurate portrayal of shipping and weather, reflects the artist's interest in Flemish and Italian idealized landscape. It draws upon sketches from Place's 'Large Sketchbook' made at Scarborough in 1717. The ships are of Dutch build of the third quarter of the seventeenth century, suggesting that Place has used a Dutch source.

33 Samuel Scott *Two Boats with Crews . . .*, 1735–6. Cat. 16.
The study relates to the two boatloads of figures pushing off from the stern of the flagship in *A Flagship Shortening Sail* (1736), probably commissioned by William, 3rd Earl Fitzwilliam (National Maritime Museum). The painting may commemorate the departure for Lisbon in May 1735 of John Norris, Commander-in-Chief in the Mediterranean.

34 Willem van de Velde the Younger *Two Dutch Yachts and Several Ships at Anchor*, c.1700. Cat. 9.
Towards the end of his life, perhaps for the benefit of studio assistants, Van de Velde the Younger made a number of instructional drawings dealing with the subject of perspective. In this example the horizon line has been ruled in and marked at five points with vertical lines each numbered 20. The inscription at the top reads: 'The horizon or vanishing point from which I measure. In the following, I shall take examples at 10 feet and five feet, take the distance from the base line to have room enough, as numbered here.' Inscribed at bottom right is: 'Note the looking up or the looking down with a high horizon.'

35

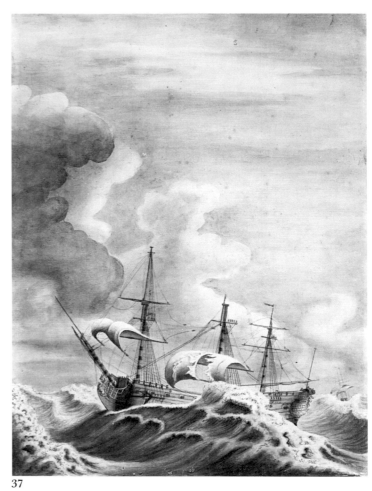

37

36

Eighteenth-century Shipping and Coastal Views

Throughout the eighteenth century naval ships provided subjects for marine artists such as Brooking, and for less well known ones such as John Harris. In the second half of the eighteenth century the British coastline and its craft were widely drawn and painted by marine artists. Some, like John Thomas Serres, Charles Gore and perhaps Robert Cleveley, travelled further afield to the Mediterranean.

35 Thomas Baston *A First-rate Man-of-war in a Calm at Sun Rising*, 1718. Cat. 14.

This is a drawing for one of the engravings for the *Twenty two Prints of several of the CAPITAL SHIPS of his Maj.ties ROYAL NAVY with Variety of other SEA PIECES after the Drawings of T. Baston*' (c.1721). Little is known of this draughtsman, who may have relied upon the work of other contemporary artists, such as Monamy or Sailmaker.

36 Charles Brooking *An English Two-decker*. Cat. 20.

This drawing of a naval two-decker is as complete as any of Brooking's oil paintings in the detailed observation of both the vessel and the conditions under which it is sailing.

37 John Hood (ascribed to) *The English Ship Liverpool*, c.1750. Cat. 22.

The traditional ascription to John Hood is doubtful. The inscription on the back of the drawing of HMS *Duke* (Cat. 21) states that the ship was 'Commanded by Sir John Bentley in the year 1745 & 1746 of which this drawing is a correct Portrait made at the time of Sir Johns command by his Clerk.' The drawings are in some ways similar to later known drawings by Francis Swaine, particularly in the stylized treatment of the sea. In this connection it is interesting that in 1735 Swaine is listed as a messenger in a list of clerks and officers employed by the naval Treasurer and Commissioners.

38

39

40

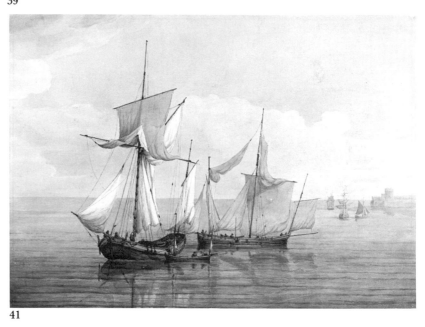

41

38 John Harris *Men-of-war Lying off Sheerness*, c.1800. Cat. 62.
Harris was also a painter of insects, fruit, flowers, and 'subjects in Rustic life', often employed by booksellers and publishers for the illustration of books. His marine drawings are very like those of the Cleveley brothers, John the Younger and Robert.

39 Francis Swaine *A Lugger Close-hauled in a Strong Breeze*. Cat. 25.
Many of Swaine's drawings have a whimsical quality. The sea is sometimes highly stylized and fanciful coastlines appear in the background, as in this example. The shipping, however, is always accurately portrayed and sometimes rare depictions of seldom drawn craft, such as colliers, occur, as in another drawing in the Greenwich Collection. The lugger here is close-hauled, that is, sailing almost into the wind, and it is clear that Swaine has a thorough knowledge of the way in which the craft is being sailed.

40 Dominic Serres *Calshot Castle with Shipping in Southampton Water*, c.1789. Cat. 44.
Characteristic of a number of wash drawings of general shipping subjects produced towards the end of the eighteenth century, this drawing by Dominic Serres is reminiscent of similar examples by Robert Cleveley (such as Cat. 36).

41 John Thomas Serres *A Hoy and a Lugger with other Shipping on a Calm Sea*. Cat. 61.
A view probably taken in the English Channel. The foreground craft are drying their sails.

42

43

42 Robert Cleveley *A Polacca and Men-of-war in Light Airs off Stromboli*, 1785. Cat. 36.
It is possible that Robert Cleveley visited the Mediterranean in an official capacity connected with the navy. Stromboli, an important landmark off the coast of Sicily, appears in one of the plates after Dominic Serres in the *Liber Nauticus*, also showing a *polacca*, a kind of Mediterranean craft.

43 Charles Gore *A View of Dover from the Pier*, 1767. Cat. 27.
Gore's earlier pen and wash drawings derive almost without exception from his Van de Velde studies. This comparatively early dated example, however, is almost certainly drawn from life.

44

45

44 John Thomas Serres *View of Castle Cornet, Guernsey, Channel Islands, with Shipping*, c.1800. Cat. 60.

Serres's thorough knowledge of the coast is reflected in this drawing in which the many packed boats suggest an event of some interest. Coastal views by Serres were engraved for his translation of Bougard's *Le Petit Flambeau de la Mer* (Little Sea Torch) which was published in 1801. According to Serres's own dedication, the work was suggested by Charles Cunningham, captain of HMS *Clyde*, with whom the artist 'had the honour of making two cruizes'.

45 Samuel Atkins (active 1787–1808) *East Indiaman being Refitted*, c.1787. Cat. 39.

Although there exist a number of views of eighteenth-century naval dockyards, in particular those by John Cleveley the Elder showing ships on the stocks or being launched, views of ordinary working shipyards are rare. This one is probably on the Thames at Deptford.

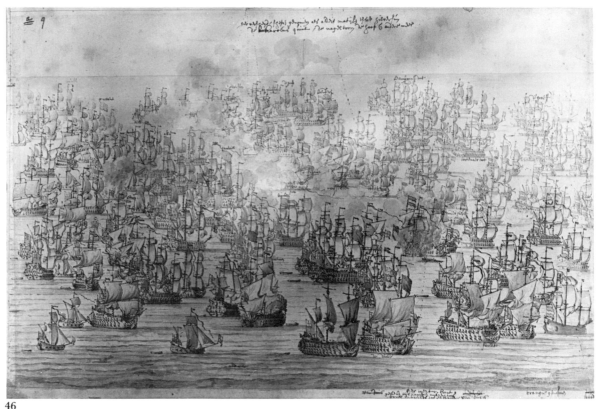

46

47

48

Naval Engagements

The naval battle is a subject which has consistently been painted and
drawn by the marine artist, sometimes based on first-hand experience but
more usually constructed from contemporary reports and descriptions.

46 Willem van de Velde the Elder *The Battle of Lowestoft, 3/13 June 1665,*
c.1674. Cat. 3.
Although the opening action of the second Anglo-Dutch war was
witnessed by Van de Velde from a galliot (which appears in the left
foreground), this drawing and its two companions date from after the
Van de Veldes' move to England, possibly 1674. They may be grouped
with further drawings also with high horizons which were intended as
designs for tapestries. The battle is shown after the blowing up of the
Eendracht, the principal Dutch flagship.

47 Peter Monamy *The Battle of Cape Passaro, 11 August 1718*. Cat. 13.
This aerial view, annotated with the names of the principal ships in this
Anglo-Spanish action off the coast of Sicily, shows Monamy's closeness to
the Van de Velde tradition. Vertue mentions Monamy's 'Early affection
to drawing of ships and vessels of all kinds and the Imitations of other
famous masters of paintings in that manner. Vande Veldes & . . .'

48 Dominic Serres *The Artois Taking Two Dutch Privateers*, c.1781. Cat. 33.
Captain McBride's official account of the capture on 3 December 1781 by
his ship the *Artois* of the *Hercules* and *Mars*, two privateers belonging to
Amsterdam, 'occasioned much mirth at the time on account of the
singular manner in which it was worded.' A connection between Serres
and Captain McBride is further suggested by the exhibition at the Royal
Academy earlier in 1781 of a picture of a previous exploit, the capture of
a Spanish ship.

49

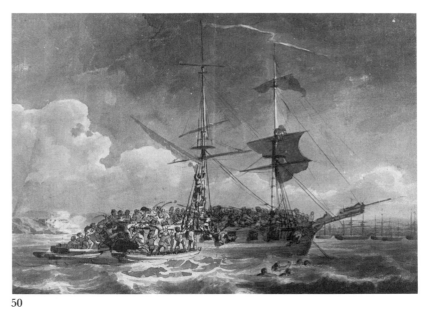

50

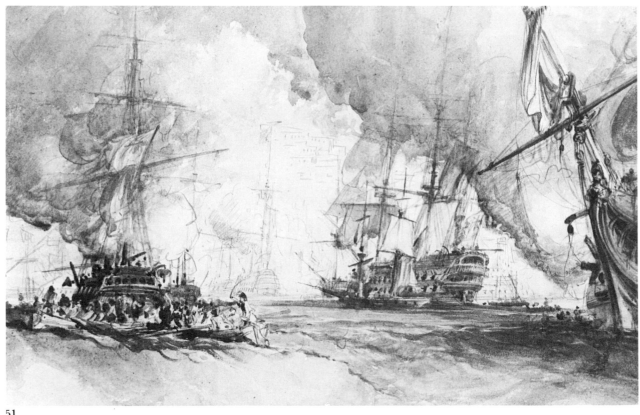

51

49 Robert Cleveley *The Battle of the First of June 1794*, 1794. Cat. 54. In the months immediately after Lord Howe's victory, Cleveley was clearly engaged on pictures of the battle, which were engraved by Medland and published in 1795 by Poggi. Farington records (9 August 1794): 'Called on Poggi . . . he desired me to give him an introduction to Admiral Gardner, that he might shew him Cleveley's designs.' On 1 October 1794 he continues: 'I went to Poggis where I found Captain Mansfield. The two drawings by Clevely [*sic*] of the action of June 1st. were there,' and finally (21 February 1795), he notes: 'Poggi I called on, who this day opened his exhibition of Clevely's [*sic*] pictures.'

50 Philippe Jacques de Loutherbourg *The Cutting out of a French Brig . . .* Cat. 63.
De Loutherbourg frequently made marine drawings in wash, some relating to his major battle pieces, such as the large *Battle of the First of*

June 1794 (Greenwich Hospital Collection). In these paintings the ships in action form a dramatic background to the struggles of the common sailors who fill the foreground. The action in this drawing is not identified, but in 1802 de Loutherbourg exhibited at the Royal Academy a similar subject, *The Cutting out of the French Corvette La Chevrette 21 July 1801*.

51 George Chambers *First Thought for the Bombardment of Algiers, 27 August 1816*, 1836. Cat. 96.
A number of studies exist for Chambers's important commission, painted for Greenwich Hospital in 1836, twenty years after the event. Although 'Chambers went to Plymouth for the express purpose of sketching men-of-war,' the picture was not generally well received at Greenwich with regard to the painting of the gunpowder smoke and the 'inky or purply haze about this picture' (Watkins, *Life of George Chambers*).

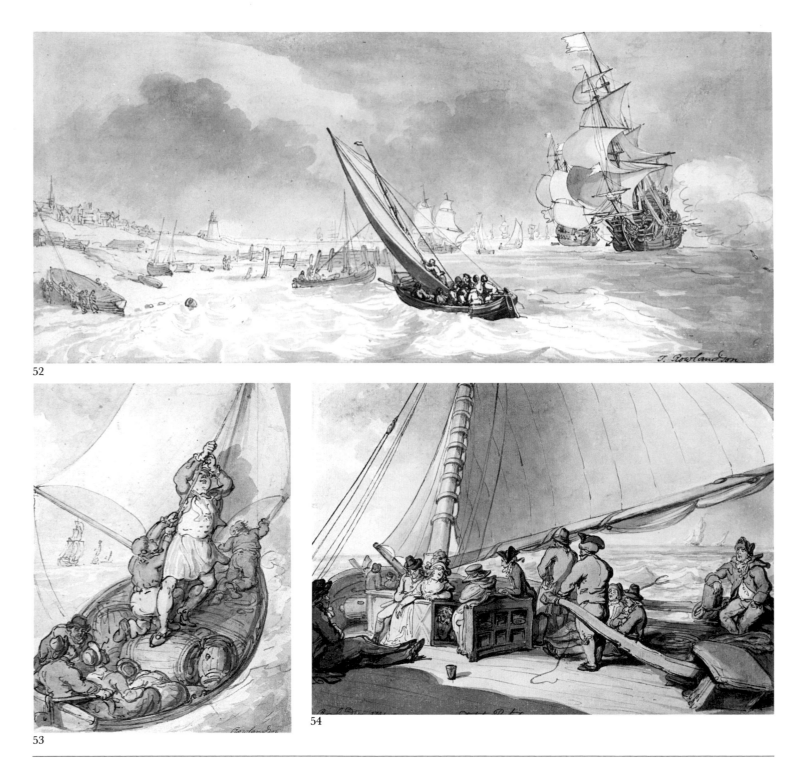

52

53

54

Rowlandson and the Sea

Rowlandson drew a considerable number of marine subjects, many concerned with sea travel, with which he was well acquainted, having crossed to the Continent on a number of occasions on his way to France, Holland, Germany and Italy. He also made visits to the coasts of Britain, and during his famous tour in a post-chaise, probably in 1784, made drawings on board the *Hector* man-of-war anchored in Portsmouth Harbour (Huntington Library, San Marino, California).

52 Thomas Rowlandson *Men-of-war and Sailing Boats near a Shore*. Cat. 49. The coastal town with lighthouse on the shore is not identified. The large warships on the right are not contemporary, but of the seventeenth century and would seem to derive from a Dutch source.

53 Thomas Rowlandson *Hoisting Sail in a Boat*. Cat. 51.

54 Thomas Rowlandson *A Dutch Packet in a Rising Breeze*, 1791. Cat. 52. Travel by sea and the associated discomfort are common themes in Rowlandson's drawings. Inscribed 1791, this drawing may date from a visit to Holland in that year.

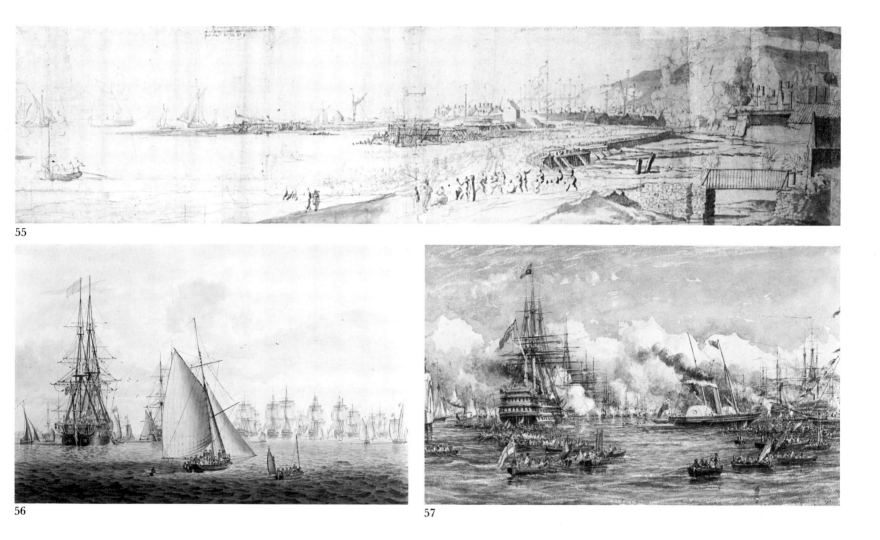

55

56

57

The Monarch and the Marine Painter

Since the seventeenth century monarchs have provided important subjects for the marine painters and draughtsmen, not only their many arrivals from and departures to the Continent, but also official reviews and visits to the fleet.

55 Willem van de Velde the Elder *Mary of Modena Landing at Dover, 21 November/1 December 1673*. Cat. 5.
One of a series of drawings showing the voyage from Calais to Dover of Mary of Modena prior to her marriage to the Duke of York. In the centre foreground the Duke is leading the future Duchess up the beach.

56 John Cleveley the Younger *King George III Reviewing the Fleet at Spithead, 22 June 1773*, 1773. Cat. 30.
George III took great interest in the navy and reviews were frequent during his reign. In June 1773 the King spent several days at Portsmouth reviewing the fleet and visiting the dockyard, ships in harbour and other official and private establishments. John Cleveley the Younger was not present at the review, having left England on 3 June with the expedition of Captain Phipps to Iceland, from which he returned in October, but his father, John Cleveley, a painter of dockyard subjects was present, and may subsequently have produced paintings.

57 William Adolphus Knell *Her Majesty's Visit to the Flagship, 11 August 1853*. Cat. 126.
Queen Victoria went on board HMS *Duke of Wellington* during a review of the fleet in August 1853. The paddle box of the *Victoria and Albert*, Queen Victoria's first yacht to bear the name, appears on the extreme left. To the left of the centre is the *Duke of Wellington*, flying the Royal Standard for the duration of the Queen's visit, and to the right the *Fairy* yacht.

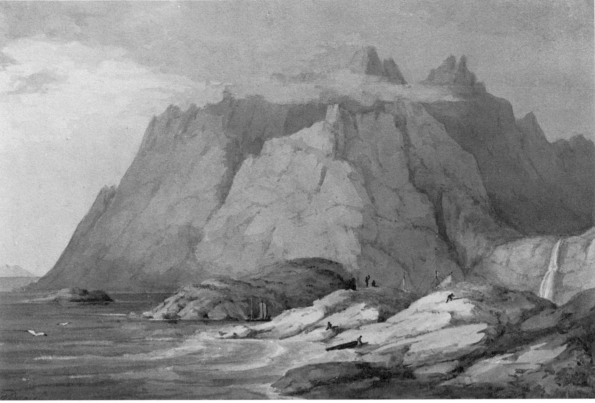

58

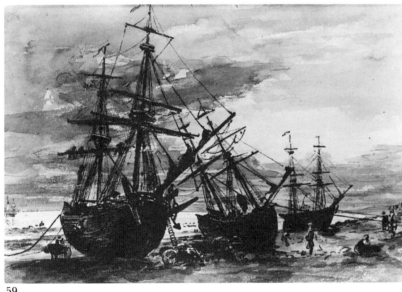

59

60

Nineteenth-century Coastal Views

The fashion for visiting the remoter parts of Britain and its coasts developed in the latter part of the eighteenth century and continued through the best part of the nineteenth. Coastal and marine subjects were taken up by a wide range of artists, some of whom also visited the Continent and found the Channel coast of France and Holland rich in marine subjects.

58 William Daniell *Loch Scavaig, Isle of Skye*, c.1816. Cat. 75.
Trained as assistant to his uncle Thomas Daniell in India, 1785–94, William Daniell was a fine aquatinter as well as an accomplished topographical draughtsman. His travels for *A Voyage Round Great Britain* occupied him between 1813 and 1823, the Scottish coasts being completed in 1815. The Scottish views are among his best. This scene was probably exhibited in 1816 at the Royal Academy (no. 383) as *View of the Coolin Mountains on the Western Coast of the Isle of Skye, taken from Loch Scavigh*. A similar, but not identical plate occurs in the *Voyage*.

59 John Constable *Coal Brigs on Brighton Beach*, c.1824. Cat. 81.
In this study of coal brigs, their hulls and rigging silhouetted against a luminous sea and sky, Constable depicts a common occurrence—the unloading of coal into horse-drawn carts from beached brigs.

60 Miles Edmund Cotman *On the Banks of the Yare, Southtown, Yarmouth*, 1836. Cat. 98.
Largely a painter of marine subjects, Miles Cotman rarely escaped the influence of his father, John Sell Cotman, whose pupil and assistant he was. Occasionally his marines are dashing and sketchlike, but more often precise. His father referred to his son's 'hard, dry manner'.

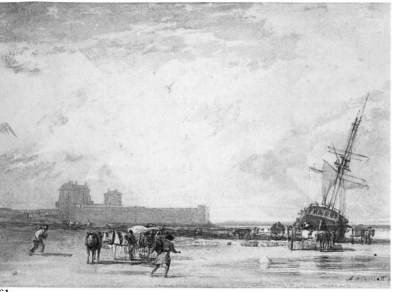

61

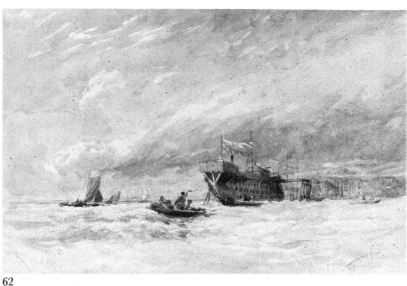

62

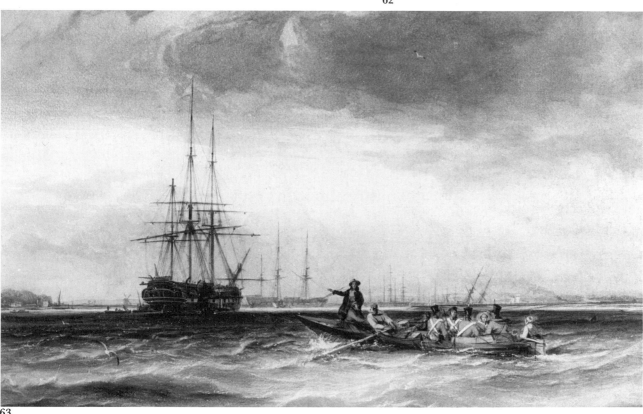

63

61 Sir Augustus Wall Callcott *Near St. Malo*. Cat. 79.
As a watercolourist Callcott was frequently at his best in coastal subjects, either in colour or in sepia. His early interest in marine subjects, which he exhibited from 1806, was no doubt stimulated by his study of Turner. Although he travelled little outside Britain before 1827, the year of his marriage, he did visit France in 1815.

62 David Cox, Sr. *On the Medway*, c.1845–50. Cat. 112.
Broad and free in handling, the powerful watercolours of Cox's later years are, in his own words (in reply to criticism that they had become too rough): 'the work of the mind, which I consider very far before portraits of places.' It would be difficult, however, to imagine so intense an image—a convict ship in a bleak and windy estuary—to have been inspired by anything but direct experience.

63 George Chambers *Soldiers being Rowed out to an Indiaman at Northfleet*, ?c.1839. Cat. 101.
In the late 1830s, 'it was observed that his [Chambers's] style of painting was becoming heavy and hard—there was not that clearness of atmosphere, that light expansive distance . . . too much of a grey tone pervaded.' Chambers was himself aware of this: 'It will not do without getting more to nature', and anticipated a sailing trip down the Thames with a view to a published work of views from Gravesend to London Bridge 'with the immense variety of shipping' (Watkins *Life of George Chambers*). Northfleet is on the south bank of the Thames to the west of Gravesend.

64

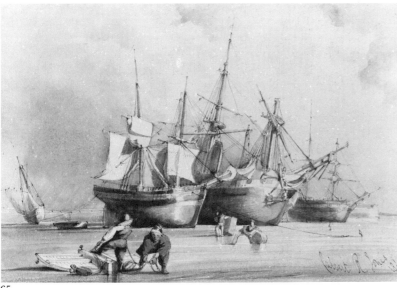

65

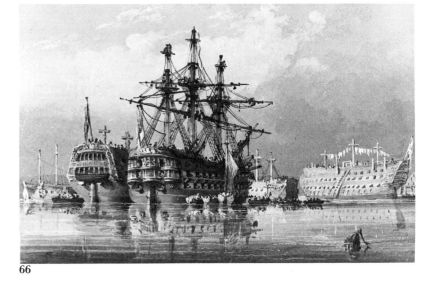

66

64 Anthony Vandyke Copley Fielding *Fishing Smacks by Clamshell Cove on the Island of Staffa . . .*, 1853. Cat. 124.
A prolific exhibitor at the Society of Painters in Water-Colours and its president from 1831 until his death in 1855, Fielding made coastal subjects one of his specialities. Although repetitive in both subject and handling, these dramatic and atmospheric scenes were popular with exhibition audiences. He painted a considerable number of views of Staffa.

65 Richard Calvert Jones *Beached Trading Vessels . . .*, 1840. Cat. 104.
The cousin of William Henry Fox Talbot, Calvert Jones is now best known as an important early photographer. He is said, however, to have worked in the studio of George Chambers, and painted mainly shipping subjects. His photographs of marine subjects are sometimes very similar to his watercolours, and an important group of calotypes of the 1840s show beached trading craft at Swansea.

66 Nicholas Condy *Ships in Ordinary at Devonport*, c.1845. Cat. 116.
Condy was a native of Plymouth, of which the naval dockyard at Devonport is part. Although there is some confusion between the work of Nicholas Condy and his son Nicholas Matthew (1818–51), it is likely that this characteristically colourful watercolour, with its heavy use of body colour on tinted paper, is by the father. The term 'in ordinary' is applied to ships which are not in commission.

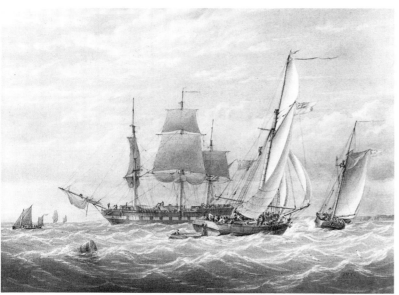

67

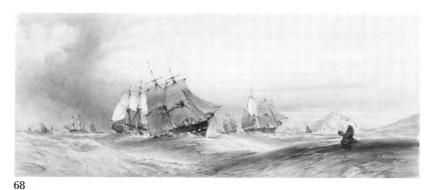

68

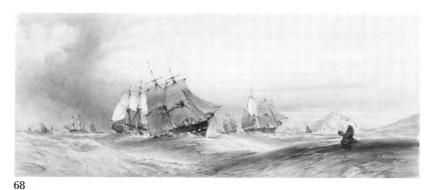

69

67 William Joy and John Cantiloe Joy *Two Cutters under Sail and a Ship at Anchor*. Cat. 115.

In about 1832 the Joy brothers moved to Portsmouth, where they worked as government draughtsmen. Their thorough knowledge of shipping is clearly demonstrated in precise and detailed draughtsmanship, while in the sea and sky atmospheric effect is achieved with a distinctive use of greens, pinks and purples, with a resulting grainy texture.

68 John Callow *Shipping off St. Michael's Mount, Cornwall*, 1866. Cat. 134. John Callow's style is based on that of his elder brother, William, whom he accompanied to Paris in 1835, eventually taking over the latter's

drawing practice. For a time during the early 1850s he worked as assistant to John Christian Schetky at the East India Company's military cadet school at Addiscombe. His subjects were mainly from the coasts of England, Wales, Normandy and the Channel Islands.

69 Edward Duncan *Off the Mumbles, South Wales*, 1860. Cat. 128. Originally trained as an engraver, Duncan was introduced to marine painting through his father-in-law, William John Huggins, whose work he engraved in aquatint. As a marine painter, however, he was more at home with coastal subjects, meticulous and detailed and frequently making use of strong blues and greens.

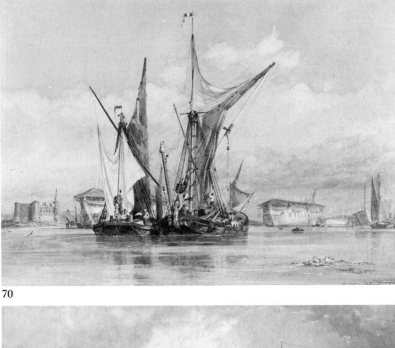

70

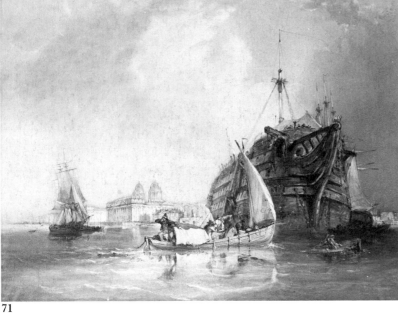

71

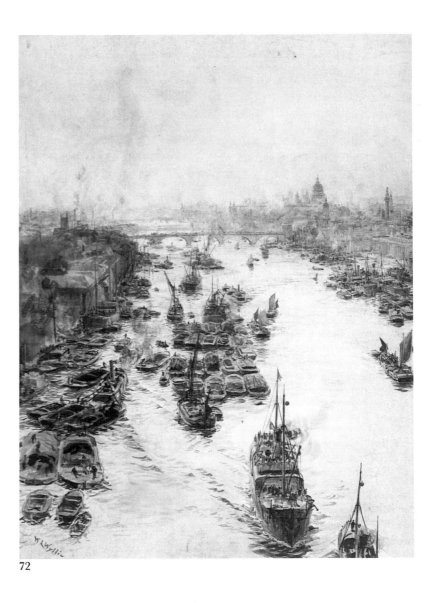

72

The Thames

Although the Thames at London had been drawn and painted by artists since the seventeenth century, in the early 1800s its subjects were increasingly exploited, from the city itself to the Medway. Greenwich and the Royal Hospital provided obvious subjects. Later, in the 1880s, W. L. Wyllie made use of the new industrial subjects of the river.

70 Edward William Cooke *Bomb-proof Battery near Gillingham on the Medway, with Thames Barges*, 1833. Cat. 93.
The complex rigging of the foreground barges exhibits Cooke's preoccupation with the mechanical working of craft. His many detailed pencil drawings of rigging and moving parts have a distinctly scientific quality. The barges are drying their sails while waiting for the tide; Cooke refers to this drawing in his notebook (no. 37) as '*Barges or "tide waiters": drying sails (calm)—off the Bombproof battery—Medway 8th July*'.

71 William Collingwood Smith *HMS Dreadnought, Seamen's Hospital off Greenwich*, 1831. Cat. 105.
Reminiscent in its low viewpoint and composition of Turner's *A First-rate Taking in Stores* (Cat. 77) Smith's watercolour shows HMS *Dreadnought* moored in the Thames on 20 June 1831. HMS *Dreadnought* (the fifth to bear the name) fought at Trafalgar in 1805 and in 1830 became a hospital ship 'for seamen of all nations'.

72 William Lionel Wyllie *The Pool of London*, c.1890. Cat. 144.
In the 1880s Wyllie's pictures concerned with the workaday aspects of the Thames brought him recognition. 'The Thames that Mr Wyllie paints is the Thames as it is, with all of its grime and much of its wonder, all its business and something of its pathos . . . its enormous testimonies to the dark romance of these coal-and-iron times' (*Magazine of Art*, 1889). This scene was exhibited at the New English Art Club, 1890.

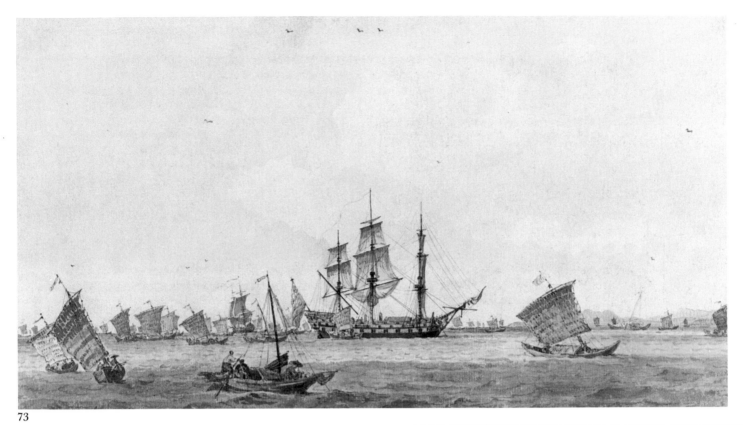

73

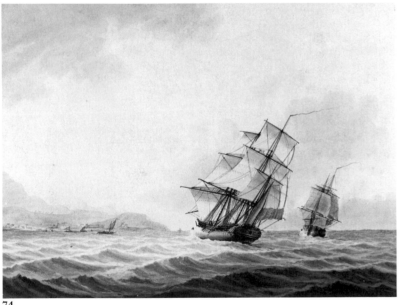

74

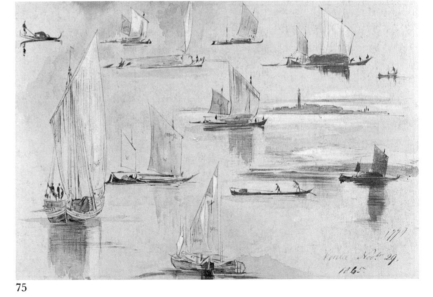

75

Discovery and Travel

In the late eighteenth century artists accompanied official scientific or diplomatic expeditions. With the opening up of travel in the 1800s, artists were able to travel far afield in their own right, not only to Europe, but to the Middle East and beyond.

73 William Alexander *The Hindostan at Anchor in the Strait of Mi-a-Tau off the City of Ten-choo-fou at the Entrance to the Gulf of Pekin, 20 July 1793*, 1793. Cat. 47.
Fifty-six of Lord Macartney's entourage sailed to China on board HMS *Lion*, the remaining thirty-nine on the *Hindostan*, one of the largest and fastest of the East India Company's ships. According to Lord Macartney's journal of his embassy to China, on 20 July 1793 'We got a new pilot from the shore, and in a few hours came abreast of the city of Tengchowfu. We now discovered that the Miao Tao is an island to the northward of us instead of being an harbour on the main as we had been led to imagine. It lies about three and a half miles eastward of Tengchowfu. We came to an anchor half way between them in eight fathom water, but veering off to fifteen. The road is bad and dangerous.'

74 Samuel Atkins *Resolution and Discovery off the Coast of Tahiti*. Cat. 38. Atkins was not present on Cook's third voyage (1776–80), and as works by him before 1787 are not known, it may be assumed that this is a later commission. In the late 1790s Atkins himself voyaged to the East Indies; he exhibited a Chinese subject in the Royal Academy in 1804.

75 Edward Lear *Studies of Venetian Craft, 29 November 1865*. Cat. 132. Lear travelled extensively, spending a large part of his life away from England. He made numerous studies of local craft, including those of Venice, Malta and the Nile.

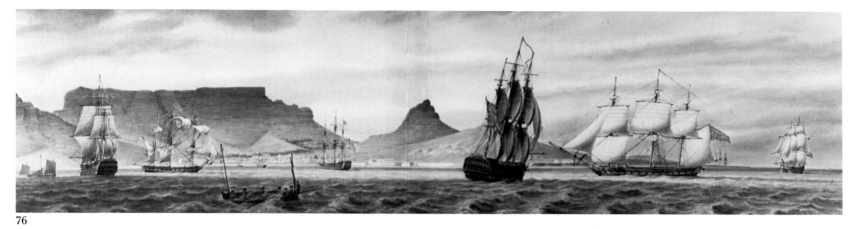

76

77

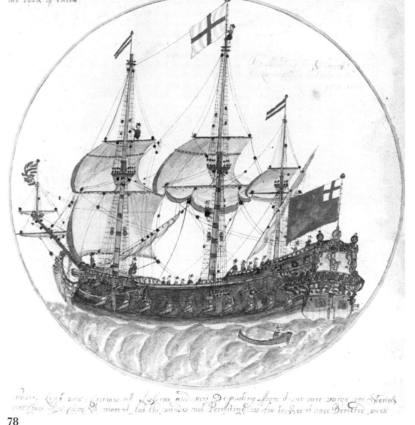

78

Naval Officers and Sketchbooks

Illustrated journals by seamen date from at least as early as the
seventeenth century, as may be seen in examples by Jeremy Roche
(Cat. 2) and Edward Barlow. Although naval officers were taught to
draw for specific reasons, for example to help identify landfalls, many
drew for recreation, particularly in the nineteenth century.

76 William Innes Pocock *View from the Anchorage in Table Bay, Cape of Good
Hope*, 1807. Cat. 74.
The second surviving sgn of Nicholas Pocock, William Innes Pocock was
second lieutenant in HMS *Eagle* on his retirement in 1814. The
Gentleman's Magazine (September 1836) referred to his 'cultivated mind,
much taste, and great talents as a draftsman; his charts being models of
accuracy and neatness, and his drawings of the various places he visited
in a very superior style.'

77 Nicholas Pocock *Log of the Lloyd . . . : A Prospect of Charles Town*, 1768.
Cat. 26.
Pocock worked for the prosperous shipowner and maker of Bristol
porcelain Richard Champion, who in 1768 appointed him to command
the barque *Lloyd* on several voyages between Bristol and South Carolina.
Pocock kept a log of each voyage illustrated with small drawings of the
ship showing the set of the sails and the weather conditions each day, as
well as a few full-page drawings.

78 Edward Barlow *Journal of his Life at Sea in King's Ships East & West
Indiamen, 1659–1703*. Cat. 1.
Edward Barlow's illustrated journal covers his remarkable life at sea on
board merchant and warships from 1659 right up until 1703 when, at the
age of sixty-one, he left the sea after the Great Storm. The coloured
drawings offer ship portraits, coastal views, shipwrecks, fish and

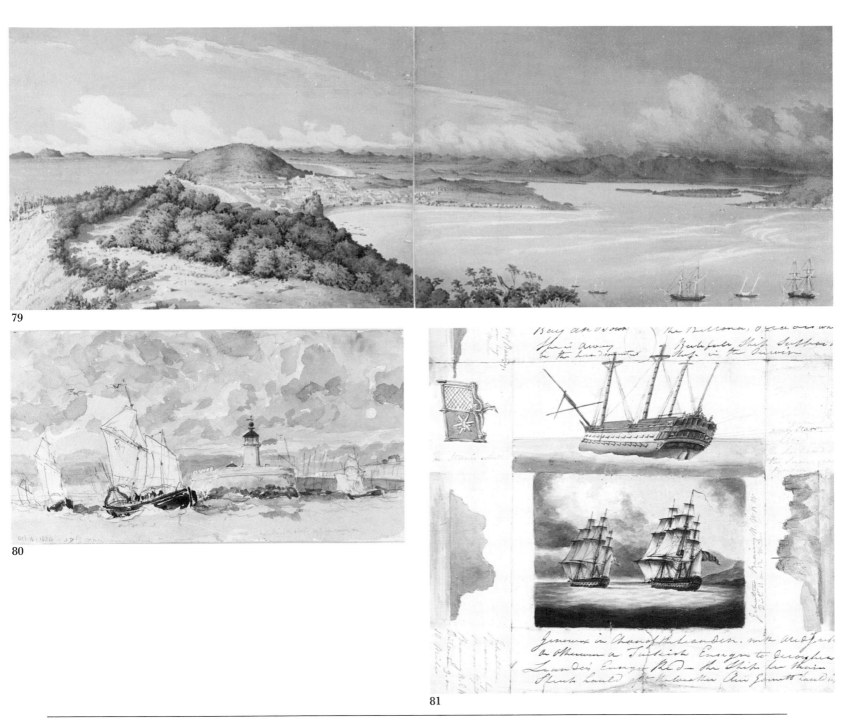

79

80

81

animals—all encountered on his voyages. In 1662 he wrote: 'we set sail from Blackwall in a ship of 400 tons, having 40 men and 34 pieces or ordnance, she being a Holland-built ship and bought in Holland about three years before, being called the *Blesing*, but when she came into England she was called the *Queen Cathrane*' (transcribed by Basil Lubbock, London, 1934).

79 Edward Gennys Fanshawe *Album No. 1: Mazatlan*, 1850. Cat. 121. Fanshawe was captain of the corvette *Daphne* (18) on the Pacific station. Despite a hurricane which entirely dismasted HMS *Daphne* at anchor off Mazatlan in November 1850, Fanshawe painted a number of typically vivid watercolours.

80 Oswald Walters Brierly *Album Leaf: Fishing Boats*, 1834. Cat. 123. Although a professional artist Brierly frequently sailed on naval ships, including two survey voyages on the Australian coast with Owen Stanley

in the 1840s, a voyage to the Black Sea with the Hon. Harry Keppel on HMS *Meander* in 1850, and a voyage round the world, 1867–8, on HMS *Galatea* commanded by the Duke of Edinburgh. Many of his more informal watercolours, such as this rapid sketch of fishing boats on a blustery day, have an exceptional atmospheric quality.

81 William Guido Anderson *Illustrated Letter to his Father, William Anderson*, 1800. Cat. 59.

The younger Anderson had exhibited one naval picture at the Royal Academy in 1799, *The Wolverine Engaging Two French Luggers*. As a midshipman in the *Bellona* he was mortally wounded at the battle of Copenhagen (2 April 1801). The letter is written from the *Bellona*, which appears in the centre drawings. The other two drawings show the *Genereux* trying to board the *Leander* on 18 August 1798. Note also the coastal views of Cape Spartel and Gibraltar.

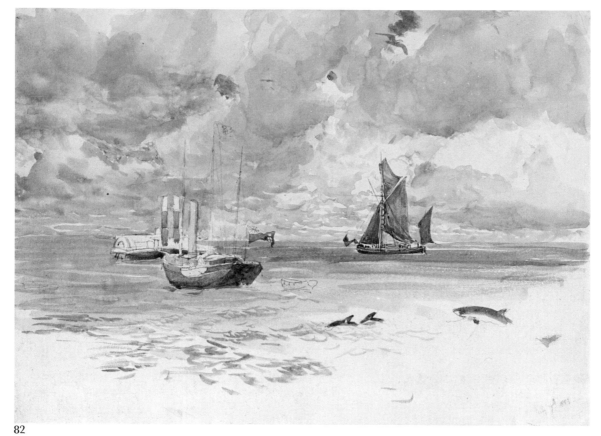

82

83

84

Later Artists

Marine painting in the years after about 1880 embraces a wide range of differing attitudes, from those like Dixon and Wyllie, whose interests veered towards specialist illustration, to the etchers of the early decades of this century, who turned to the coastlines of Britain. Others, like Fraser and Everett, are hard to categorize.

82 Henry Moore *Porpoises, 7 July 1883*. Cat. 137.
During the 1880s and 1890s a number of artists, among them John Brett, Henry Moore and W. L. Wyllie, produced paintings of 'Sea and Sky', sometimes quite empty except, perhaps, for a sail. In his watercolours, loosely painted but carefully observed, Moore recorded the changing aspects of sea and sky as well as interesting features of shipping and marine life.

83 Nelson Dawson *The Cockle Lightship, near Great Yarmouth*, c.1890. Cat. 143.
Dawson made many studies on the east coast of England that are direct and full of atmosphere. Originally part of a Chelsea circle which included Whistler, Short and Brangwyn, Dawson had a thorough knowledge of seamanship. He later turned to etching, making use of the soft ground technique in which he etched many marine and other subjects.

84 William Lionel Wyllie *Thames Barges in the Medway*, c.1900. Cat. 148.
Wyllie settled between 1884 and 1906 on the Medway, where he was surrounded by the ordinary subjects, such as Thames barges, with which he made his name in the 1880s. Wyllie made many studies of Thames barges (Cat. 145) (he owned and sailed his own), but equally he repeatedly experimented in watercolour with the varying effects of sea and sky, at their best in the fluid watercolours of the years around 1900.

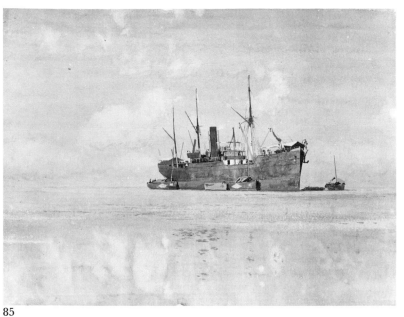

85

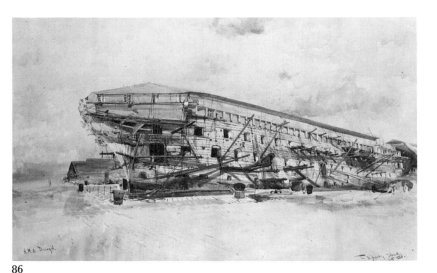

86

87

85 John Fraser *The Steamer Pickwick.* Cat. 151.
Fraser's paintings and drawings are very much those of a seaman; he sailed to America in 1885 and travelled widely during the next twenty years. It is not known where he studied, but his work is close to that of Thomas Somerscales and Edouardo de Martino whom he assisted.

86 Thomas Bush Hardy *HMS Donegal in Dry Dock,* 1885. Cat. 139.
Hardy's better work was produced in the 1870s and 1880s, after which it became unpleasantly hasty and repetitive. This untypical, but impressive drawing was presumably made from life in Portsmouth dockyard.

87 William Lionel Wyllie *Berck Plage,* 1891. Cat. 147.
Wyllie's early watercolours of French fisherfolk and their boats on the beaches of northern France are among his most beautiful. During 1891 Wyllie and his family spent a holiday at Berck-sur-Mer, resulting in elegant and spacious watercolours of holidaymakers on the beach. Some were included the following year in a one-man show at the Fine Art Society called *Holiday Drawings in France and Italy,* with an accompanying narrative by Mrs Wyllie.

Catalogue

1 Edward Barlow (b.1642) *Journal of his Life at Sea in King's Ships East & West Indiamen, 1659–1703.* PLATE 78. Watercolour with pen and ink, 14¼ × 9¼ in (36 × 23.7 cm). National Maritime Museum. Individual pages (pp. 35–36, including drawing of the *Queine Katren*) from the Journal are shown, as the volume is at present unbound for conservation purposes. The intention is to rebind it, replacing the traditional form of paper repair by present methods of treatment in keeping with the nature of the document.

2 Jeremy Roche *Journal 1659–92: Drawing of the Charles Galley.* Chiefly HMS *Antelope*, 1665–7, and *Charles Galley*, 1689–91. 7½ × 4 in (19 × 12 cm). National Maritime Museum.

3 Willem van de Velde the Elder (1611–93) *The Battle of Lowestoft 3/13 June 1665*, c.1674. PLATE 46. Pen and brown ink with grey wash over graphite on laid paper, 13¾ × 19¾ in (34.8 × 50.3 cm). National Maritime Museum.

4 Willem van de Velde the Elder (1611–93) *The Four Days' Battle: the Fleets Engaged*, probably on the first day, 1/11 June 1666. PLATE 16. Graphite and wash on laid paper, 7½ × 11⅛ in (19.1 × 28.4 cm). National Maritime Museum.

5 Willem van de Velde the Elder (1611–93) *Mary of Modena Landing at Dover, 21 November/ 1 December 1673.* PLATE 55. Graphite and wash on laid paper, 10¾ × 45 in (27.2 × 114.2 cm). National Maritime Museum.

6 Willem van de Velde the Elder (1611–93) *Portrait of the Mordaunt*, ?1681. PLATE 5. Graphite and grey wash on laid paper, 25 × 14½ in (63.5 × 36.2 cm). National Maritime Museum.

7 Bernard de Gomme (1620–85) and Thomas Phillips (?1635–93) *Channel Islands Survey: A Prospect of St. Peter's Port and Castle Cornett in the Island of Guernsey*, 1680. PLATE 3. Watercolour, 19⅞ × 36⅜ in (50.5 × 92.3 cm). National Maritime Museum.

8 Willem van de Velde the Younger (1633–1707) *A Fight in Boats*, ?1685. Broad pen and brown ink with grey wash on laid paper, 8½ × 12¾ in (21.6 × 32.3 cm). National Maritime Museum.

9 Willem van de Velde the Younger (1633–1707) *Two Dutch Yachts and Several Ships at Anchor*, c.1700. PLATE 34. Pen and brown ink with grey wash on laid paper, 9⅛ × 14¾ in (23.3 × 36.5 cm). National Maritime Museum.

10 Willem van de Velde the Younger (1633–1707) *An English Flagship Scudding in a Heavy Sea*, ?1700. Pen and brown ink with grey wash on laid paper, 5⅞ × 6⅛ in (15.1 × 15.5 cm); signed. National Maritime Museum.

11 Francis Place (1647–1728) *Coquet Island.* Pen and black ink with brown wash over graphite on laid paper, 3¼ × 16¾ in (8.1 × 42.5 cm). Yale.

12 Francis Place (1647–1728) *Men-of-war in a Storm*, c.1717. PLATE 32. Pen and ink with brown and grey wash on laid paper, 7 × 12⅜ in (18 × 31.5 cm). Whitworth Art Gallery, University of Manchester.

13 Peter Monamy (1681–1749) *The Battle of Cape Passaro, 11 August 1718.* PLATE 47. Pen and black ink with grey wash on laid paper, 9⅞ × 14¾ in (25.5 × 36.5 cm); signed. National Maritime Museum.

14 Thomas Baston (d.1721) *A First-rate Man-of-war in a Calm at Sun Rising*, 1718. PLATE 35. Pen and ink with grey wash and traces of yellow pigment on vellum, 7¾ × 11⅞ in (19.6 × 30.3 cm); signed and dated 1718. National Maritime Museum.

15 Samuel Scott (c.1702–1772) *Ships Wrecked off a Rocky Coast.* Black and grey wash over traces of graphite on laid paper, 9⅞ × 15⅜ in (25 × 39 cm); signed. National Maritime Museum.

16 Samuel Scott (c.1702–72) *Two Boats with Crews—Study for the Painting 'The Royal William at Sea', now known as 'A Flagship Shortening Sail'*, 1735–6. PLATE 33. Grey wash over graphite over guide lines incised with sharp point, some test lines and blots of brown ink in lower portion, on off-white laid paper, 5¾ × 10¾ in (14.8 × 27.2 cm). Yale.

17 Peircy Brett (1709–81) *The West Prospect of Staten Island . . . A View of Streight le Maire . . .*, early 1740s. PLATE 2. Grey wash with red ink wash on laid paper, 14⅞ × 21⅜ in (37.8 × 54.3 cm). National Maritime Museum.

18 Charles Brooking (1723–59) *The Taking of the Nuestra Señora de los Remedios by the Prince Frederick, Duke and Prince George, privateers, 5 February 1746.* PLATE 8. Pen and ink with grey wash on laid paper, 11⅜ × 17⅞ in (29 × 45.4 cm); signed and dated 1746. National Maritime Museum.

19 Charles Brooking (1723–59) *Two Frigates before the Wind.* PLATE 7. Pen and black ink with grey wash on off-white laid paper, 7⅞ × 10³⁄₁₆ in (20.1 × 25.9 cm). Yale.

20 Charles Brooking (1723–59) *An English Two-decker.* Pen and ink with grey wash on laid paper, 12⅝ × 12 in (32.1 × 30.5 cm). Victoria and Albert Museum, London.

21 John Hood (fl.1762–71) (ascribed to) *The English Ship Duke, 90 guns*, c.1750. Pen and black ink with grey wash over traces of graphite on laid paper, 13¼ × 10 in (33.7 × 25.7 cm). National Maritime Museum.

22 John Hood (fl.1762–71) (ascribed to) *The English Ship Liverpool, 28 guns*, c.1750. PLATE 37. Pen and ink with grey wash over traces of graphite on laid paper, 13¼ × 9⅞ in (33.9 × 25.4 cm). National Maritime Museum.

23 Dominic Serres (1722–93), *The Arrival of Princess Charlotte at Harwich, September 1761.* PLATE 9. Watercolour with pen and black ink on laid paper, 13¾ × 21¼ in (35.1 × 54 cm); signed and dated 1761. National Maritime Museum.

24 Francis Swaine (fl.1761–82) *A Calm Day with an East Indiaman Anchored in an Estuary.* Grey wash on laid paper, 14¼ × 21¼ in (36.4 × 54 cm); signed. National Maritime Museum.

25 Francis Swaine (fl.1761–82) *A Lugger Close-hauled in a Strong Breeze.* PLATE 39. Pen and ink with grey wash on laid paper, 10½ × 15⅞ in (26.8 × 40.5 cm); signed. National Maritime Museum.

26 Nicholas Pocock (1740–1821) *Log of the Lloyd on Voyages to South Carolina and back, 21 June– 4 November 1767: A Prospect of Charles Town.* PLATE 77. Pen and ink and grey wash, 12⅞ × 8½ in (32.8 × 21.5 cm). National Maritime Museum.

27 Charles Gore (1729–1807) *A View of Dover from the Pier,* 1767. PLATE 43. Pen and ink with watercolour over traces of graphite on laid paper, 7⅞ × 28¼ in (20 × 72 cm); dated 1767. National Maritime Museum.

28 ?Willem van de Velde the Younger (1633–1707) and Charles Gore (1729–1807) *Two Dutch Flagships,* early 1780s (Gore). PLATE 6. Watercolour with body colour on laid paper, 7⅞ × 12⅚₆ in (20 × 31.4 cm). National Maritime Museum.

29 Charles Gore (1729–1807) *A Cutter and a Lugger in a Fresh Breeze.* Watercolour with body colour over traces of graphite on wove paper, 5⅞ × 12¾ in (14.6 × 32.4 cm). National Maritime Museum.

30 John Cleveley the Younger (1747–86) *King George III Reviewing the Fleet at Spithead, 22 June 1773,* 1773. PLATE 56. Watercolour over graphite with touches of white heightening on Whatman paper, 15½ × 23½ in (39 × 64 cm). National Maritime Museum.

31 William Hodges (1744–94) *The Resolution in the Marquesas,* 1774. PLATE 1. Pen and ink with wash on laid paper, 11⅜ × 9¼ in (28.9 × 23.1 cm). National Maritime Museum.

32 John Webber (c.1750–93) *The Resolution and Adventure in Nootka Sound,* 1778. PLATE 10. Pen and ink with watercolour on laid paper, 23½ × 58½ in (59.8 × 148.6 cm). National Maritime Museum.

33 Dominic Serres (1722–93) *The Artois Taking Two Dutch Privateers,* c.1781. PLATE 48. Pen and black ink with grey wash on laid paper, 10½ × 14¼ in (26.8 × 37 cm); signed. National Maritime Museum.

34 William Hodges (1744–97) *A View of Funchall from the Sea,* c.1783. Pen and black ink with grey wash on laid paper, 16⅝ × 61¾ in (42.2 × 156 cm). National Maritime Museum.

35 Robert Cleveley (1747–1809) *The Duke of Clarence Landing at Stade, Prussia, 1 August 1783.* COLOUR PLATE 8. Watercolour, 18⅛ × 22⅜ in (46.1 × 57 cm). National Maritime Museum.

36 Robert Cleveley (1747–1809) *A Polacca and Men-of-war in Light Airs off Stromboli,* 1785. PLATE 42. Pen and black ink with grey wash on laid paper, 5⅞ × 10⅜ in (15 × 26.3 cm); signed and dated 1785. National Maritime Museum.

37 Dominic Serres (1722–93) and ?Willem van de Velde the Younger (1633–1707) *Charles II's Visit to the Combined French and English Fleets in the Thames, probably 5 June 1672,* 1785 (Serres). PLATE 4. Pen and ink with grey wash on laid paper, 14 × 24⅛ in (35.6 × 61.4 cm). National Maritime Museum.

38 Samuel Atkins (active 1787–1808) *Resolution and Discovery off the Coast of Tahiti.* PLATE 74. Watercolour with traces of graphite on wove paper, 13⅝ × 18½ in (34.5 × 46.8 cm); signed. National Maritime Museum.

39 Samuel Atkins (active 1787–1808) *East Indiaman being Refitted,* c.1787. PLATE 45. Watercolour touched with body colour over graphite on wove paper, 11¾ × 17 in (28.8 × 43.2 cm); signed. Yale.

40 Samuel Atkins (active 1787–1808) *Under Repair—an East Indiaman Drawn up for Repairs in a Busy Yard,* c.1790. COLOUR PLATE 6. Watercolour, pen and grey ink and touches of graphite on wove paper, 4 × 12 in (10.2 × 30.1 cm); signed. National Maritime Museum.

41 Nicholas Pocock (1740–1821) *A Cutter and a Man-of-war off Corsica,* 1788. Watercolour over graphite on wove paper, 10¼ × 14⅞ in (26.2 × 37.7 cm); signed and dated 1788. National Maritime Museum.

42 Dominic Serres (1722–93) *A 74-gun Ship in the Solent,* c.1788. COLOUR PLATE 10. Watercolour with pen and ink on wove paper, 11⅝ × 17⅛ in (29.4 × 43.4 cm). National Maritime Museum.

43 Dominic Serres (1722–93) *Dutch Shipping.* Watercolour with pen and black ink over graphite on off-white laid paper, 7⅛ × 9⅝ in (18.1 × 24.2 cm). Yale.

44 Dominic Serres (1722–93) *Calshot Castle with Shipping in Southampton Water,* c.1789. PLATE 40. Pen and black ink with grey wash and scratching out over graphite on off-white laid paper, 6⅜ × 9⁹₁₆ in (16.3 × 23.3 cm); signed. Yale.

45 William Alexander (1767–1816) *Fisherpeople on a Junk,* 1793. Watercolour (primarily grey and brown washes) and graphite on wove paper, 5⅞ × 8⅛ in (14.7 × 20.5 cm); signed and dated 1793. Yale.

46 William Alexander (1767–1816) *A Pleasure Junk,* 1793. COLOUR PLATE 5. Watercolour with graphite on wove paper, 5¾ × 8 in (13.6 × 20.5 cm); signed and dated 1793. National Maritime Museum.

47 William Alexander (1767–1816) *The Hindostan at Anchor in the Strait of Mi-a-Tau off the City of Ten-choo-fou at the Entrance to the Gulf of Pekin, 20 July 1793,* 1793. PLATE 73. Watercolour, pen and grey ink over graphite on laid paper, 8⅛ × 15 in (20.6 × 38.3 cm); signed. Yale.

48 John 'Warwick' Smith (1749–1831) *Bay Scene in Moonlight,* 1787. PLATE 17. Watercolour with scratching out over graphite on wove paper, 13½ × 20⅛ in (34 × 51.1 cm); signed and dated 1787. Yale.

49 Thomas Rowlandson (1756–1827) *Men-of-war and Sailing Boats near a Shore.* PLATE 52. Pen and reddish-brown and blue inks with brown and blue washes over graphite on wove paper, 8⅛ × 18¼ in (20.6 × 46.4 cm); signed. Yale.

50 Thomas Rowlandson (1756–1827) *Landing from the Packet (landing at the Medina, Isle of Wight).* Watercolour with pen and ink on wove paper, 6⅝ × 9⅞ in (17 × 25.1 cm). National Maritime Museum.

51 Thomas Rowlandson (1756–1827) *Hoisting Sail in a Boat.* PLATE 53. Watercolour with pen and ink over traces of graphite on wove paper, 7¾ × 5½ in (18.6 × 14 cm); signed. National Maritime Museum.

52 Thomas Rowlandson (1756–1827) *A Dutch Packet in a Rising Breeze,* 1791. PLATE 54. Pen and grey ink and watercolour, 7¾ × 10¾ in (19.7 × 27.3 cm); signed and dated 1791. Paul Mellon Collection, Upperville, Virginia.

53 John Thomas Serres (1759–1825) *A View of the Island of Procida near Naples*, 1791. Pen, black ink and watercolour with traces of graphite on wove paper, 10¾ × 17 in (27.5 × 43 cm); signed and dated 1791. National Maritime Museum.

54 Robert Cleveley (1747–1809) *The Battle of the First of June 1794*, 1794. PLATE 49. Pen and brown ink with brown and grey washes over traces of graphite on wove paper, 11⅞ × 18¾ in (30.4 × 47.6 cm); signed and dated. National Maritime Museum.

55 Nicholas Pocock (1740–1821) *Le Juste and the Invincible at the Battle of the First of June 1794*, 1794. PLATE 11. Watercolour over graphite, 5⅞ × 9¾ in (15 × 24.8 cm). National Maritime Museum.

56 Nicholas Pocock (1740–1821) *Men-of-war at Anchor in a Calm*, 1794. COLOUR PLATE 4. Watercolour over traces of graphite on wove paper, 16⅜ × 22⅜ in (41.7 × 56.8 cm); signed and dated 1794. National Maritime Museum.

57 William Staples (fl.1796) *Coastal Views in the English Channel : Entrance of Plymouth Sound*, 1796. Watercolour over traces of graphite, 7⅞ × 19¼ in (20 × 49 cm). National Maritime Museum.

58 William Anderson (1757–1837) *A Frigate Awaiting a Pilot*, 1797. COLOUR PLATE 9. Watercolour with pen and grey and brown inks over graphite on wove paper, 7⅞ × 11¾ in (20 × 29.8 cm); signed and dated 1797. Yale.

59 William Guido Anderson (d.1801) *Illustrated Letter to his Father, William Anderson*, 1800. PLATE 81. Watercolour with pen and ink, 16¾ × 10⅝ in (42.3 × 27 cm). National Maritime Museum.

60 John Thomas Serres (1759–1825) *View of Castle Cornet, Guernsey, Channel Islands, with Shipping*, c.1800. PLATE 44. Watercolour with pen and black ink over graphite on wove paper, 9⅜ × 26¼ in (23.8 × 66.5 cm); signed. Yale.

61 John Thomas Serres (1759–1825) *A Hoy and a Lugger with other Shipping on a Calm Sea*. PLATE 41. Watercolour with pen and black ink over graphite on wove paper, 13⅛ × 18⅝ in (33.3 × 47.5 cm). Yale.

62 John Harris, Sr. (1767–1832) *Men-of-war Lying off Sheerness*, c.1800. PLATE 38. Watercolour, pen and black ink and body colour over graphite on off-white laid paper, 16¼ × 21¼ in (41.2 × 54 cm); signed. Yale.

63 Philippe Jacques de Loutherbourg (1740–1812) *The Cutting out of a French Brig, perhaps la Chevrette, 21 July 1801*. PLATE 50. Pen and black ink with grey wash over traces of graphite on thick laid paper, 15⅛ × 21¾ in (38.5 × 55.2 cm). National Maritime Museum.

64 Edward Henry Columbine (c.1763–1811) *Entrance to English Harbour, Antigua*, 1789. PLATE 14. Watercolour, 15⅜ × 20½ in (39 × 52 cm). National Maritime Museum.

65 John Constable (1776–1837) *Shipping under a Cloudy Sky in the Thames*, 1803. PLATE 22. Grey wash 7⅞ × 12¾ in (19.7 × 32.3 cm). Victoria and Albert Museum, London.

66 Thomas Hearne (1744–1817) *A Scene on Board HMS Deal Castle, Captain J Cumming, on a Voyage from the West Indies in the year 1775*, 1804. PLATE 15. Pen and ink and watercolour over graphite on wove paper, 7⅞ × 6⅛ in (18.9 × 15.5 cm); signed and dated 1804. National Maritime Museum.

67 Nicholas Pocock (1740–1821) *Holograph to Richard Bright Esq., Bristol*, 1804. Watercolour sketch giving details of tones produced using three colours, 11 × 7½ in (28 × 18.9 cm); dated 6 February 1804. National Maritime Museum.

68 Samuel Owen (1768–1857) *Ships in a Stormy Sea*, 1806. Watercolour, pen and brown ink and scratching out over graphite on wove paper, 5½ × 11¼ in (14 × 28.5 cm); signed and dated 1806. Yale.

69 Samuel Owen (1768–1857) *Shipping on a Stormy Day*. PLATE 18. Pen and grey ink with grey wash over graphite on wove paper, 4½ × 11⅞ in (11.3 × 29.8 cm); signed. Yale.

70 Samuel Owen (1768–1857) *Sailing Ships and Small Boats in a Rough Sea off the Coast*. COLOUR PLATE 3. Watercolour, pen and black ink, body colour and scratching out over graphite on wove paper, 5¼ × 4¾ in (13.3 × 10.9 cm). Yale.

71 John Samuel Hayward (1778–1822) *Penzance Pier from the Dolphin Inn Window, 15 October 1807*, 1807. Watercolour over graphite on off-white wove paper, 7⅛ × 21 in (18 × 53.4 cm); signed and dated 1807. Yale.

72 François Louis Thomas Francia (1772–1839) *Boats on a Stormy Sea*, c.1808. PLATE 19. Watercolour with scratching out over graphite on rough-textured wove paper, 4⅛ × 7⅛ in (10.5 × 18 cm); signed. Yale.

73 John Sell Cotman (1782–1842) *Boat on the Beach*, 1808. Watercolour over graphite on wove paper, 11¼ × 18¾ in (28.6 × 47.6 cm). Victoria and Albert Museum, London.

74 William Innes Pocock (1783–1836) *View from the Anchorage in Table Bay, Cape of Good Hope*, 1807. PLATE 76. Pen and ink with watercolour, 10⅛ × 29 in (25.8 × 73.6 cm). National Maritime Museum.

75 William Daniell (1769–1837) *Loch Scavaig, Isle of Skye*, c.1816. PLATE 58. Watercolour and body colour with scratching out over graphite on wove paper, 8⅜ × 12⅜ in (21 × 31.5 cm); signed. Yale.

76 Joseph Mallord William Turner (1775–1851) *Tor Bay from Brixham*, c.1816–17. COLOUR PLATE 21. Watercolour, 6¼ × 9⅝ in (15.8 × 24 cm). The Syndics of the Fitzwilliam Museum, Cambridge.

77 Joseph Mallord William Turner (1775–1851) *A First-rate Taking in Stores*, 1818. PLATE 25. Graphite and watercolour, 11⅛ × 15⅝ in (28.6 × 39.7 cm); signed and dated 1818. Cecil Higgins Art Gallery, Bedford.

78 Samuel Prout (1783–1852) *An East Indiaman Ashore*, c.1821. COLOUR PLATE 12. Watercolour, pen and ink, with surface scratching, 19½ × 26¾ in (49.5 × 68 cm). Whitworth Art Gallery, University of Manchester.

79 Sir Augustus Wall Callcott (1779–1844) *Near St. Malo*. PLATE 61. Watercolour with scratching out and touches of body colour over graphite on off-white wove card, 7⅛ × 10⅛ in (18 × 25.4 cm); signed. Yale.

80 John Constable (1776–1837) *Fishing Boat with Net*, 1824. PLATE 23. Watercolour, 7 × 10¼ in (17.8 × 26 cm). Victoria and Albert Museum, London.

81 John Constable (1776–1837) *Coal Brigs on Brighton Beach*, c.1824. PLATE 59. Watercolour over graphite on wove paper, 7 × 10½ in (17.8 × 26.7 cm). Cecil Higgins Art Gallery, Bedford.

82 Richard Parkes Bonington (1802–28) *Vessels in a Choppy Sea*, c.1824–5. COLOUR PLATE 27. Watercolour touched with body colour and scratching out on wove paper, $5\frac{1}{2} \times 8\frac{3}{8}$ in (14×21.4 cm). Yale.

83 William John Huggins (1781–1845) *The Launch of the Honourable East India Company's Ship Edinburgh*, c.1825. COLOUR PLATE 23. Watercolour and body colour with gum arabic heightening, $14\frac{5}{8} \times 22\frac{1}{2}$ in (37.2×57.1 cm). National Maritime Museum.

84 John Thomas Serres (1759–1825) *The Arrival of His Majesty George the Fourth in Scotland, Accompanied by the Royal Flotilla, August 1822*. COLOUR PLATE 7. Pen and ink and watercolour over graphite on wove paper, $13 \times 35\frac{1}{4}$ in (33.2×89.8 cm); signed and dated 1822. National Maritime Museum.

85 Joseph Mallord William Turner (1775–1851) *Whiting Fishing off Margate*, 1822. COLOUR PLATE 1. Watercolour, body colour, gum, graphite and scratching out on wove paper, $16\frac{7}{8} \times 25\frac{3}{8}$ in (42.8×64.5 cm); signed and dated 1822. Yale.

86 Richard Parkes Bonington (1802–28) *Sailing Vessels in an Estuary*, c.1826. PLATE 21. Watercolour touched with body colour, pen and brown ink and scratching out over graphite on wove paper, $5\frac{3}{4} \times 9$ in (14.6×22.9 cm); signed. Yale.

87 David Cox, Sr. (1783–1859) *Entrance to Calais Harbour*, ?1827. COLOUR PLATE 15. Watercolour touched with body colour and scratching out over graphite on heavy wove paper, $7\frac{3}{8} \times 11\frac{1}{8}$ in (18.8×28.3 cm); signed and dated ?1827. Yale.

88 Joseph Mallord William Turner (1775–1851) *Folkestone Harbour and Coast to Dover*, c.1829. Watercolour, body colour, gum and scratching out on wove paper, $11\frac{3}{8} \times 17\frac{7}{8}$ in (28.8×45.5 cm). Yale.

89 François Louis Thomas Francia (1772–1839) *A Stricken Vessel in a Gale*, 1830. PLATE 20. Watercolour with pen and reddish-brown ink, $12\frac{3}{4} \times 18\frac{1}{4}$ in (32.4×46.4 cm); signed and dated 1830. Private collection, London.

90 John Sell Cotman (1782–1842) *Study of Sea and Gulls*, 1832. COLOUR PLATE 11. Watercolour with some quill penwork and scraping out on wove paper, $9\frac{1}{8} \times 11\frac{3}{4}$ in (23.3×29.8 cm); signed and dated 1832. Victoria and Albert Museum, London.

91 George Chambers (1803–40) *On the Thames*, 1833. Watercolour on wove paper, 8×11 in (20.2×27.8 cm); signed and dated 1833. Victoria and Albert Museum, London.

92 Edward William Cooke (1811–80) *Hay Barge and Men-of-war on the Medway*, 1833. COLOUR PLATE 20. Watercolour and body colour, scratching out and gum over graphite on wove paper, $9 \times 12\frac{3}{4}$ in (23×32.5 cm); signed and dated 1833. National Maritime Museum.

93 Edward William Cooke (1811–80) *Bomb-proof Battery near Gillingham on the Medway, with Thames Barges*, 1833. PLATE 70. Watercolour with body colour, pen and brown ink, scratching out and gum over graphite on wove paper, $8\frac{5}{8} \times 12\frac{3}{8}$ in (22.1×31.5 cm). Yale.

94 Richard Calvert Jones (1804–77) *Nymph, Yacht, Belonging to Lord Harborough*, 1834. Watercolour over graphite on wove paper, $6\frac{7}{8} \times 10\frac{3}{8}$ in (17.5×26.5 cm); dated 1834. National Maritime Museum.

95 George Chambers (1803–40) *A Frigate Firing a Gun*, c.1835. COLOUR PLATE 28. Watercolour over graphite with scraped highlights on wove paper, $7\frac{1}{4} \times 11\frac{3}{4}$ in (18.4×28.8 cm). National Maritime Museum.

96 George Chambers (1803–40) *First Thought for the Bombardment of Algiers, 27 August 1816*, 1836. PLATE 51. Brown wash over graphite on wove paper, $8 \times 13\frac{1}{4}$ in (20.4×33.6 cm). National Maritime Museum.

97 Clarkson Stanfield (1793–1867) *Cutting Away the Masts*, c.1836. COLOUR PLATE 18. Watercolour, body colour with varnish and surface scratching on wove paper, $10\frac{1}{8} \times 15\frac{1}{8}$ in (26.2×39 cm). Whitworth Art Gallery, University of Manchester.

98 Miles Edmund Cotman (1810–58) *On the Banks of the Yare, Southtown, Yarmouth*, 1836. PLATE 60. Watercolour on wove paper, $6\frac{1}{2} \times 9\frac{1}{8}$ in (16.4×23.2 cm); signed and dated 1836. Victoria and Albert Museum, London.

99 John Sell Cotman (1782–1842) and Miles Edmund Cotman (1810–58) *Lee Shore, with the Wreck of the Houghton Pictures, Books, etc., Sold to the Empress Catherine of Russia*, 1838. PLATE 26. Graphite and watercolour with body colour and gum arabic on wove paper, $26\frac{3}{4} \times 35\frac{1}{2}$ in (68×90.2 cm). The Syndics of the Fitzwilliam Museum, Cambridge.

100 Miles Edmund Cotman (1810–58) *Seascape with Sailing Boats*, 1839. Watercolour on wove paper, $3\frac{3}{4} \times 6\frac{3}{4}$ in (9.4×16.9 cm); signed and dated 1839. Victoria and Albert Museum, London.

101 George Chambers (1803–40) *Soldiers being Rowed out to an Indiaman at Northfleet*, ?c.1839. PLATE 63. Watercolour and body colour with scratching out and gum over graphite on wove paper, $15\frac{7}{8} \times 25\frac{7}{8}$ in (40.2×65.7 cm). Yale.

102 Joseph Mallord William Turner (1775–1851) *Sunset at Sea, with Gurnets*, c.1840. PLATE 27. Watercolour and body colour with black chalk and scratching out on buff-grey paper, $8\frac{1}{2} \times 11\frac{1}{8}$ in (21.8×28.4 cm). Whitworth Art Gallery, University of Manchester.

103 William Callow (1812–1908) *Plymouth Dockyard after the Fire*, c.1840. COLOUR PLATE 24. Watercolour, body colour and gum over graphite on wove paper, $13\frac{5}{8} \times 20\frac{3}{8}$ in (34.6×51.8 cm). Yale.

104 Richard Calvert Jones (1804–77) *Beached Trading Vessels and Fishermen with Block and Tackle in Foreground, ?Swansea*, 1840. PLATE 65. Pen and brown ink and watercolour on wove paper, $7 \times 10\frac{1}{8}$ in (17.7×25.6 cm); signed and dated 1840. National Maritime Museum.

105 William Collingwood Smith (1815–87) *HMS Dreadnought, Seamen's Hospital off Greenwich*, 1831. PLATE 71. Watercolour with body colour, white highlights and gum arabic heightening on wove paper, $24\frac{3}{4} \times 32\frac{7}{8}$ in (63×83.5 cm); signed. National Maritime Museum.

106 Alfred Herbert (c.1820–61) *A Schooner and a Dutch Vessel Close-hauled in St. Helier's Bay, Jersey*, 1846. COLOUR PLATE 19. Watercolour and body colour over graphite with scraped highlights on wove paper, $14\frac{3}{4} \times 29\frac{1}{4}$ in (37.5×74.3 cm); signed and dated 1846. National Maritime Museum.

107 Humphrey John Julian (d.1850) *The Admiral's House, Simon's Town, Cape of Good Hope*, 1844. COLOUR PLATE 30. Watercolour touched with body colour and scratching out over graphite on wove paper, $9 \times 14\frac{1}{8}$ in (22.9×35.9 cm); signed and dated 1844. Yale.

108 Charles Bentley (1806–54) *Coast Scene with Shipping.* COLOUR PLATE 16.
Watercolour, pen and brown ink and scratching out over graphite on wove paper, 9⅜ × 14¾ in (23.7 × 37.6 cm). Yale.

109 Clarkson Stanfield (1793–1867) *Dutch Fishing Vessels by a Quay,* ?1840s.
Watercolour touched with body colour and some scratching out over graphite on wove paper, 17½ × 12¾ in (44.4 × 32.3 cm). Yale.

110 Thomas Sewell Robins (c.1814–80) *Louis Philippe's Visit to Queen Victoria, October 1844.*
Watercolour, 7¾ × 19⅜ in (19.5 × 49.3 cm); signed and dated 1844.
National Maritime Museum.

111 Thomas Sewell Robins (1814–80) *Mutton Cove, Plymouth.* COLOUR PLATE 26.
Watercolour with body colour and scratching out over graphite on wove paper, 8¾ × 11 in (21.2 × 28 cm); signed. Yale.

112 David Cox, Sr. (1783–1859) *On the Medway,* c.1845–50. PLATE 62.
Watercolour with body colour and charcoal over graphite on heavy-textured 'scotch' paper, 19 × 29¼ in (48.2 × 74 cm). Yale.

113 William Joy (1803–67) *HMS Vanguard, St. Vincent and a Royal Yacht at Spithead,* 1850s. COLOUR PLATE 29.
Watercolour with body colour on wove paper, 7¾ × 11⅜ in (19.7 × 28.9 cm).
National Maritime Museum.

114 William Joy (1803–67) *Dutch Fishing Boats at Anchor in an Estuary,* ?1850s. COLOUR PLATE 22.
Watercolour with pen and brown ink, scratching out and gum over graphite on wove paper, 11⅜ × 16⅜ in (28.9 × 41.4 cm). Yale.

115 William Joy (1803–67) and John Cantiloe Joy (1806–66) *Two Cutters under Sail and a Ship at Anchor.* PLATE 67.
Watercolour and body colour on wove paper, 14⅜ × 19⅝ in (36.6 × 49.8 cm); signed.
National Maritime Museum.

116 Nicholas Condy (1793–1857) *Ships in Ordinary at Devonport,* c.1845. PLATE 66.
Watercolour and body colour on grey wove paper, 4¼ × 6⅜ in (10.7 × 16.2 cm).
National Maritime Museum.

117 Nicholas Condy (1793–1857) *A Yawl,* c.1845.
Watercolour and body colour on grey wove paper, 3¾ × 4¾ in (9.4 × 12 cm); signed.
National Maritime Museum.

118 Charles Bentley (1806–54) *Shipping off Scarborough,* 1848.
Watercolour with scraped highlights and some graphite on wove paper, 19¾ × 30¼ in (50.2 × 77 cm); signed and dated 1848.
National Maritime Museum.

119 Anthony Vandyke Copley Fielding (1787–1855) *The Head of Loch Fyne, with Dindarra Castle,* 1850.
Watercolour and body colour with scratching out and gum over graphite on wove paper, 12 × 16 in (30.3 × 40.6 cm); signed and dated 1850. Yale.

120 George Pechell Mends (d.?1872) *Sketchbook — Malta, Mediterranean, England: HMS Trafalgar,* 1850s. PLATE 13.
Watercolour over traces of graphite with pen and ink, 10 × 14½ in (25.5 × 36.8 cm).
National Maritime Museum.

121 Edward Gennys Fanshawe (1814–1906) *Album No. 1: Mazatlan,* 1850. PLATE 79.
Watercolour with scratching out, 9 × 12¾ in (22.7 × 65 cm).
National Maritime Museum.

122 Oswald Walters Brierly (1817–94) *HMS Rattlesnake,* 1853.
Watercolour with body colour over graphite, 5¼ × 8¼ in (13.5 × 21 cm).
National Maritime Museum.

123 Oswald Walters Brierly (1817–94) *Album Leaf: Fishing Boats.* PLATE 80.
Watercolour over graphite, 5¾ × 11 in (14.5 × 28 cm); dated 1834.
National Maritime Museum.

124 Anthony Vandyke Copley Fielding (1787–1855) *Fishing Smacks by Clamshell Cove on the Island of Staffa with Iona in the Distance,* 1853. PLATE 64.
Watercolour with body colour over graphite with scraping out on wove paper, 17⅞ × 30½ in (45.3 × 77.2 cm); signed and dated 1853.
National Maritime Museum.

125 Clarkson Stanfield (1793–1867) *HMS Victory Towed into Gibraltar, 28 October 1805, with the Body of Nelson on Board,* 1853. COLOUR PLATE 17.
Watercolour over graphite with white heightening on wove paper, 22¼ × 30¾ in (56.5 × 78 cm).
National Maritime Museum.

126 William Adolphus Knell (c.1808–75) *Her Majesty's Visit to the Flagship, 11 August 1853.* PLATE 57.
Watercolour and body colour with scraped highlights on wove paper, 9¾ × 16 in (24.8 × 40.7 cm).
National Maritime Museum.

127 John Wilson Carmichael (1800–68) *The Building of the Great Eastern,* 1857. COLOUR PLATE 25.
Watercolour over graphite, 8½ × 12⅝ in (21.7 × 32 cm); signed and dated 1857.
National Maritime Museum.

128 Edward Duncan (1803–82) *Off the Mumbles, South Wales,* 1860. PLATE 69.
Watercolour and body colour over graphite with scraped highlights on wove paper, 14 × 29⅜ in (34.4 × 74.7 cm) (sight); signed and dated 1860.
National Maritime Museum.

129 Edward Duncan (1803–82) *Sailing Barge at Sea.*
Watercolour with scratching out and touches of body colour over graphite on off-white wove paper, 9¼ × 12⅝ in (23.4 × 32 cm); signed. Yale.

130 John Christian Schetky (1778–1874) *The Rock of Lisbon,* 1861. PLATE 12.
Watercolour over graphite, 5 × 13 in (12.7 × 33 cm); signed and dated 1861.
National Maritime Museum.

131 John Christian Schetky (1778–1874) *Shipping Becalmed off a Port by Moonlight.*
Brown wash with pen and brown ink over traces of graphite, 10⅞ × 15¼ in (27.5 × 38.7 cm); signed.
National Maritime Museum.

132 Edward Lear (1812–88) *Studies of Venetian Craft, 29 November 1865.* PLATE 75.
Pen and brown ink with watercolour on pale blue wove paper, 9½ × 13¾ in (24 × 34.8 cm); dated 1865.
National Maritime Museum.

133 Edward Lear (1812–88) *Manfaloot — 5.5.am 4 March 1867.*
Pen and brown ink with watercolour over traces of graphite on wove paper, 3 × 6⅞ in (7.6 × 17.6 cm); dated 1867.
National Maritime Museum.

134 John Callow (1822–78) *Shipping off St. Michael's Mount, Cornwall,* 1866. PLATE 68.
WatercolouR, pen and brown and blue inks and scratching out over graphite on wove paper, 10 × 24 in (25.4 × 60.9 cm); signed and dated 1866. Yale.

135 Alfred William Hunt (1830–96) *'Blue Lights,' Tynemouth Pier — Lighting the Lamps at Sundown,* 1866–8. COLOUR PLATE 31.
Watercolour, body colour, scratching and sanding out on wove paper, 14⅝ × 21¼ in (37.2 × 54 cm); signed and dated 1868. Yale.

136 Henry Moore (1831–95) *A Squally Day,* 1879.
Watercolour on wove paper, 10⅛ × 14⅞ in (25.8 × 37.8 cm); signed and dated 1879.
Victoria and Albert Museum, London.

137 Henry Moore (1831–95) *Porpoises, 7 July 1883.* PLATE 82. Watercolour with graphite on off-white wove paper, 10 × 13⅞ in (25.4 × 35.4 cm); dated 1883. Yale.

138 Hercules Brabazon Brabazon (1821–1906) *Mouth of the Humber: after Turner.* PLATE 31. Watercolour touched with body colour, scratching out and graphite accents over graphite on grey wove paper, 6⅛ × 9⅞ in (15.6 × 25.1 cm); signed. Yale.

139 Thomas Bush Hardy (1842–97) *HMS Donegal in Dry Dock,* 1885. PLATE 86. Watercolour, 25⅞ × 41⅜ in (65.8 × 105.2 cm); signed and dated 1885. National Maritime Museum.

140 James Abbott McNeill Whistler (1834–1903) *Beach Scene,* 1883–4. PLATE 28. Watercolour, 4¾ × 8⅛ in (12 × 20.7 cm) (sight). Collection of Mr and Mrs Paul Mellon, Upperville, Virginia.

141 James Abbott McNeill Whistler (1834–1903) *The Return of the Fishing Boats,* c.1890. PLATE 29. Watercolour, 8⅛ × 4⅝ in (20.8 × 11.6 cm) (sight). Collection of Mr and Mrs Paul Mellon, Upperville, Virginia.

142 Henry Moore (1831–95) *Lowestoft,* 1888. COLOUR PLATE 2. Watercolour on wove paper, 11⅛ × 15¼ in (28.2 × 38.8 cm); signed and dated 1888. Victoria and Albert Museum, London.

143 Nelson Dawson (1860–1943) *The Cockle Lightship, near Great Yarmouth,* c.1890. PLATE 83. Watercolour and graphite on wove paper, 11½ × 15 in (29 × 38.2 cm). National Maritime Museum.

144 William Lionel Wyllie (1851–1931) *The Pool of London,* c.1890. PLATE 72. Grey wash over graphite on wove paper, 23¾ × 18⅛ in (60.6 × 46.1 cm); signed. National Maritime Museum.

145 William Lionel Wyllie (1851–1931) *Album Leaf: Studies of Thames Barges.* Brown wash, 10 × 8⅝ in (25.6 × 21.9 cm). National Maritime Museum.

146 William Lionel Wyllie (1851–1931) *Straits of Gibraltar,* c.1890. COLOUR PLATE 14. Watercolour over graphite, 8¼ × 16½ in (20.7 × 42 cm); signed. National Maritime Museum.

147 William Lionel Wyllie (1851–1931) *Berck Plage,* 1891. PLATE 87. Watercolour and body colour over graphite on wove paper, 7¼ × 16⅝ in (18.5 × 42.2 cm); signed. National Maritime Museum.

148 William Lionel Wyllie (1851–1931) *Thames Barges in the Medway,* c.1900. PLATE 84. Watercolour on wove paper, 11¼ × 18⅛ in (28.5 × 46.4 cm). National Maritime Museum.

149 William Lionel Wyllie (1851–1931) *Yachts at Anchor,* c.1900. COLOUR PLATE 13. Watercolour on wove paper, 9⅞ × 13⅞ in (25.2 × 35.4 cm). National Maritime Museum.

150 John Fraser (1858–1927) *The Whitstable Hoy,* 1908. Watercolour on wove paper, 15½ × 21⅞ in (39.3 × 55.7 cm); signed and dated. National Maritime Museum.

151 John Fraser (1858–1927) *The Steamer Pickwick.* PLATE 85. Watercolour and some body colour on wove paper, 15¾ × 20⅜ in (39 × 51.8 cm). National Maritime Museum.

152 Charles Dixon (1872–1934) *Carmania Sinking Cap Trafalgar off Trinidad 14 September 1914,* 1923. Watercolour with white heightening, 10 × 14¾ in (25 × 37.5 cm) (sight); signed and dated 1923. National Maritime Museui.

153 Philip Wilson Steer (1860–1942) *A Grey Day,* 1919. PLATE 30. Watercolour on wove paper, 9⅝ × 13⅝ in (24.5 × 34.5 cm). Victoria and Albert Museum, London.

154 John Everett (1876–1949) *Deck Scene, Kylemore, Barque,* c.1930. COLOUR PLATE 32. Watercolour with body colour over graphite on grey wove paper, 22 × 16½ in (57.7 × 42.8 cm); signed. National Maritime Museum.

Bibliography

E. H. H. Archibald *A Dictionary of Sea Painters,* Woodbridge, 1981

D. E. R. Brewington *Dictionary of Marine Artists,* Salem and Mystic, 1982

D. Brook-Hart *British 19th Century Marine Painting,* Woodbridge, 1974

D. Brook-Hart *20th Century British Marine Painting,* Woodbridge, 1981

D. Cordingly *Marine Painting in England 1700–1900,* London, 1981

D. Cordingly *Painters of the Sea, A Survey of Dutch and English Marine Painters from British Collections* (exhibition catalogue), London and Brighton, 1979

W. Gaunt *Marine Painting An Historical Survey,* London, 1975

P. Kemp & R. Ormond, *The Great Age of Sail,* Oxford, 1986

O. Warner, *An Introduction to British Marine Painting,* London, 1948

Lenders

Bedford, Cecil Higgins Art Gallery: 77, 81

Cambridge, Syndics of the Fitzwilliam Museum: 76, 99

London, National Maritime Museum: 1, 2, 3, 4, 5, 6, 7, 8, 9, 10, 13, 14, 15, 17, 18, 21, 22, 23, 24, 25, 26, 27, 28, 29, 30, 31, 32, 33, 34, 35, 36, 37, 38, 40, 41, 42, 46, 50, 51, 53, 54, 55, 56, 57, 59, 63, 64, 66, 67, 74, 83, 84, 92, 94, 95, 96, 104, 105, 106, 110, 113, 115, 116, 117, 118, 120, 121, 122, 123, 124, 125, 126, 127, 128, 130, 131, 132, 133, 139, 143, 144, 145, 146, 147, 148, 149, 150, 151, 152, 154

London, The Board of Trustees of the Victoria and Albert Museum: 20, 65, 73, 80, 90, 91, 98, 100, 136, 142, 153

London, Private Collection: 89

Manchester, Whitworth Art Gallery, University of Manchester: 12, 78, 97, 102

Upperville, Virginia, Paul Mellon Collection: 52

Upperville, Virginia, Collection of Mr and Mrs Paul Mellon: 140, 141

Yale Center for British Art (Paul Mellon Collection): 11, 16, 19, 39, 43, 44, 45, 47, 48, 58, 60, 61, 62, 68, 69, 70, 71, 72, 75, 79, 82, 86, 87, 88, 93, 101, 103, 107, 108, 109, 111, 112, 114, 119, 129, 134, 137, 138; (Yale University Art Gallery Collection, Gift of Allen Evarts Foster, BA 1906) 49; (Paul Mellon Fund) 85, 135

We are very grateful to the lenders listed above for kindly supplying photographs of their loans, and for allowing us to reproduce them here.

Index